NAME THEM
THEY FLY BET

Published by
Maverick Books, an imprint of
Trinity University Press
San Antonio, Texas 78212

Book design by Garrick Gott
Photography by Marks Moore,
Emily Walter, and Dudley Harris

ISBN 978-1-59534-819-7 paperback
ISBN 978-1-59534-820-3 ebook

Trinity University Press strives to produce
its books using methods and materials in
an environmentally sensitive manner. We
favor working with manufacturers that
practice sustainable management of all
natural resources, produce paper using
recycled stock, and manage forests with
the best possible practices for people,
biodiversity, and sustainability. The press
is a member of the Green Press Initiative, a
nonprofit program dedicated to support-
ing publishers in their efforts to reduce
their impacts on endangered forests,
climate change, and forest-dependent
communities.

The paper used in this publication meets
the minimum requirements of the American
National Standard for Information
Sciences—Permanence of Paper for
Printed Library Materials, ansi 39.48-1992.

CIP data on file at the Library of Congress
21 20 19 18 17 | 5 4 3 2 1

Printed and manufactured in Canada

CHRISTOPHER ORNELAS

NAME THEM —
THEY FLY BETTER
Pat Hammond's
theory of aerodynamics

with a foreword by Naomi Shihab Nye

Maverick Books / Trinity University Press
San Antonio, Texas

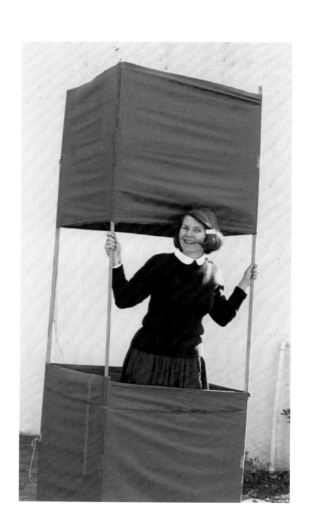

Contents

Pat invited us into her house and we wandered in the wake of her brimming chatter about projects, schemes, wild imaginings—kites, feathers, colors, fabrics, a palpable architecture of some dreamed-up design she sketched in the air. I felt the poverty of my own imaginings in her presence. I felt the buoyancy of possibility she released into the air we breathed as she swept through room after room and described a museum of new works yet to be. Like strings of kites she released into the sky, each lifting the next, the next—until a hundred diamonds beaded one string into the sky—she offered a ladder of visions that could lift us from this world to the next. Just take a step, she seemed to say, and the musical scale of creation will appear for you to follow.

—Kim Stafford, 2016

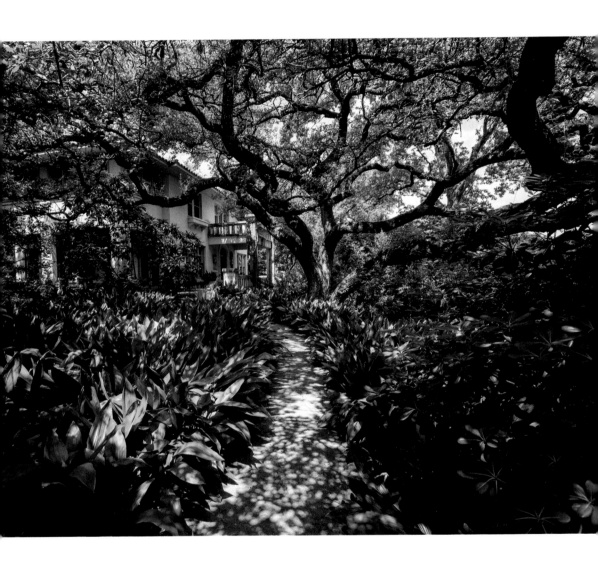

Foreword

Naomi Shihab Nye

How often does a fourth-grader say to an adult he has known for only one hour, "I really think you should meet my parents. You would be friends with my parents. So, since I don't have your phone number, here is their phone number. Please call them as soon as you can"?

Thank you, Robert Hammond, for the gift of your marvelous parents, Pat and Hall Hammond, dear friends now for decades. Who should be surprised? A boy who would become a man who could stare at an abandoned elevated overgrown railway track, envisioning a park that would change New York City, could probably spot an adult with a taste for the original.

Thank you, Pat and Hall Hammond, for trusting in your children.

You invited us over to dinner after I called—"Uh . . . Your son said we should be friends . . ."—and you already had the poem he had written in my workshop, about his magical house, framed and posted on the wall.

Truth is, my husband Michael and I love all the Hammonds, but this is a note of special reverence and respect for Pat, who quickly felt like an old, chummy friend, those many years ago, an invaluable, essential comrade, who would nearly always wear the same dress pattern in variant colors and fabrics, asking you first thing if you could translate the carefully selected march of pins or brooches across the front of it—usually a pun—with a message for the day. (Word lover that I am, I almost never could.) The person who would take your ninety-three-year-old houseguest, Dorothy Stafford, widow of the poet William Stafford (also a conscientious objector), out to fly red kites in a field at a military base. The person who would give a tea party, crowding the dining table with small clay sheep from Mexico. There before us all, a field of white wedding cookies, teacups, sheep, and handwoven joy. Nothing less, ever, with Pat. Abundance and surprise. The person who never ran out of things to talk about or question—*this? But what about that? Or maybe that other? Oh wait, let me tell you this one other thing . . .*

Once, I think, I stayed in her downstairs bathroom for about an hour, just examining it, as if in a Museum of Wondrous Curiosities. Maybe she called to me, at long last, or I glanced at my watch—remembering we were part of a day, not afloat in a timeless zone of tantalizing toys and eccentric crafts.

Another thing: If you invited Pat Hammond to attend an event—a poetry reading, lecture, slide show, art opening—she would show up. For those of us too often lost in the mysterious (often frustrating) throes of audience-building, this was a gift. She would show up, and be interested.

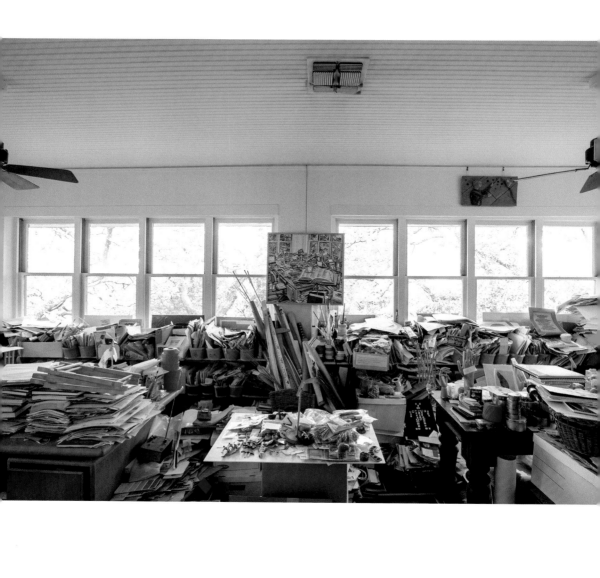

She would care.

Pat Hammond's freshness always gives a person something to think about.

You feel lit up after seeing her. Since her mind is not stuck in the same old ditch of breaking news that many of us keep stumbling into, the day swerves into the unknown.

You make excuses to pass by the Hammond house, drop something off, knowing you'll shed a little of your own dullness along the way.

As a child, I felt highly anxious if my parents took me to a home in which there were no visible books, magazines, or newspapers. Such people seemed like aliens: What did they do all the time? How could they survive? How could my parents possibly like them or wish to affiliate? Had I been taken to the Hammond home at an earlier age, with its multitudes of shelves, books, nooks, crannies, drawers, dangling artifacts, I might have attempted to homestead, stake a claim: "I think she is my long-lost auntie."

Here, for Pat, forever.
From a poem called "Toys on the Planet Earth," in *A Maze Me* (Greenwillow, 2005):

> We need carved wooden cows, kites,
> small dolls with flexible limbs.
> I vote for the sponge in the shape of a sandwich.
> Keep your bad news, world.
> Dream of something better . . .

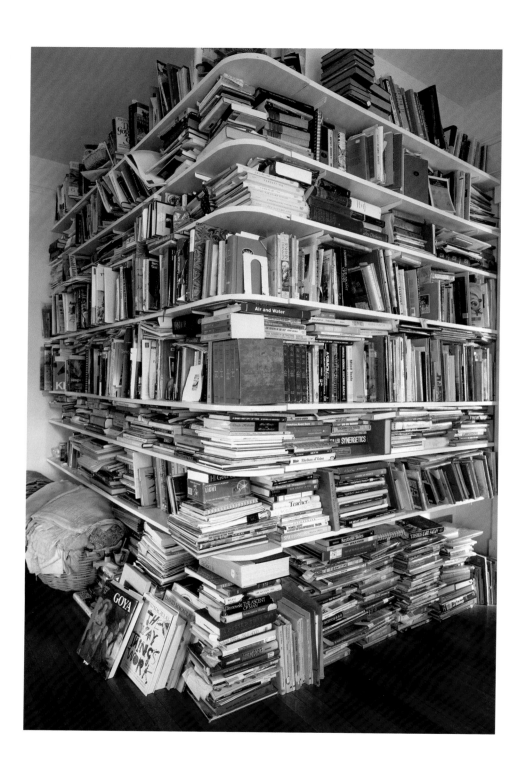

Introduction

This story begins in the spring of 2015, when I heard that Pat Hammond was about to burn her kite collection. Pat's kite collection is legendary. She has several hundred kites—collected over the course of twenty years—and she has become a well-known though elusive figure in the (admittedly small) kite world. I first met Pat several years ago, when I was writing a book about Guatemalan kites. I sought her help in uncovering the origins of this unusual kite tradition. Pat had traveled to Guatemala in the 1970s and, when she returned, had brought several rare Guatemalan kites back to the U.S.

So the news that Pat's kite collection is about to go up in flames startles me. I am amused and horrified at the same time. Not long after I hear that Pat wants to burn her kites, I also learn that she has recently been diagnosed with dementia. The illness is still in its early stages, but she is beginning to lose her short-term memory. These two pieces of news hit me hard and they put simultaneously Pat's work into jeopardy in very different ways. Pat eventually did burn parts of her kite collection—but not until after we documented the kites and donated the most valuable objects to museums. However, there is nothing we can do to reverse her diagnosis.

In the spring of 2015, I received a call from Pat's son Robert asking me to help document his mother's work. He asked, in part, because I had written about his mother before: I published an article about Pat's kites for *Discourse at the End of the Line*, the quarterly journal of the Drachen Foundation, an organization that promotes the study of kite artists and cultures around the world.

More importantly, however, Pat is a self-taught artist whose work deserves to be documented and saved—as much as one can save her work without altering its ephemeral quality. Although Pat's kite collection is known within a limited world of artists, her other art—the great body of collections that fill her home—is virtually unknown.

Pat is partly complicit in her own obscurity. She often made things for her own personal amusement. She does not seek public recognition for her work. Others found magic and satisfaction in her creations largely because Pat guided them through her home as she narrated her creations. And now that she has dementia, there is a very real possibility that her art, in its full form, may be lost forever.

Pat's home serves as a gallery space for her endless obsessions. It is filled with collections from floor to ceiling. Kites are only one of her passions. She also collects vertebrae, kaleidoscopes, baskets, bubble

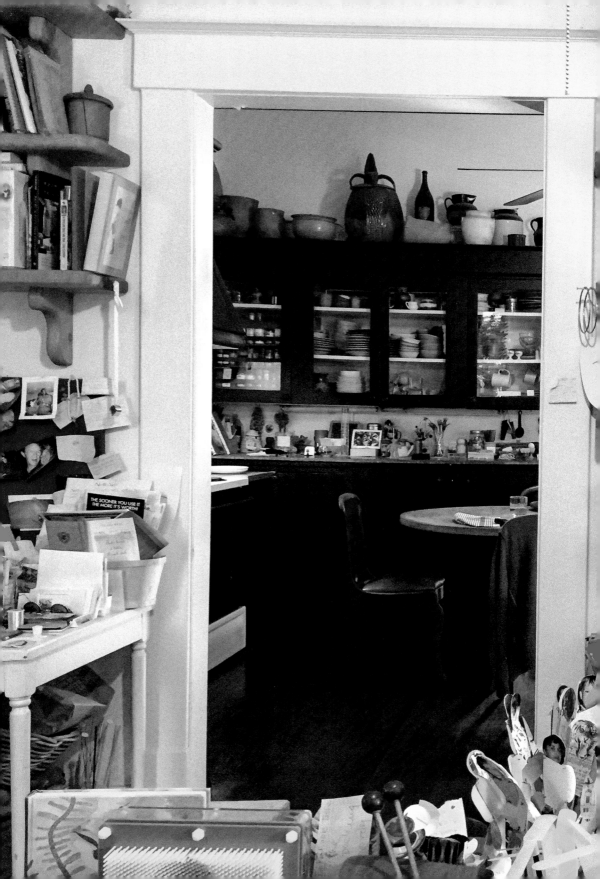

THE SOONER YOU USE IT
THE MORE IT'S WORTH!

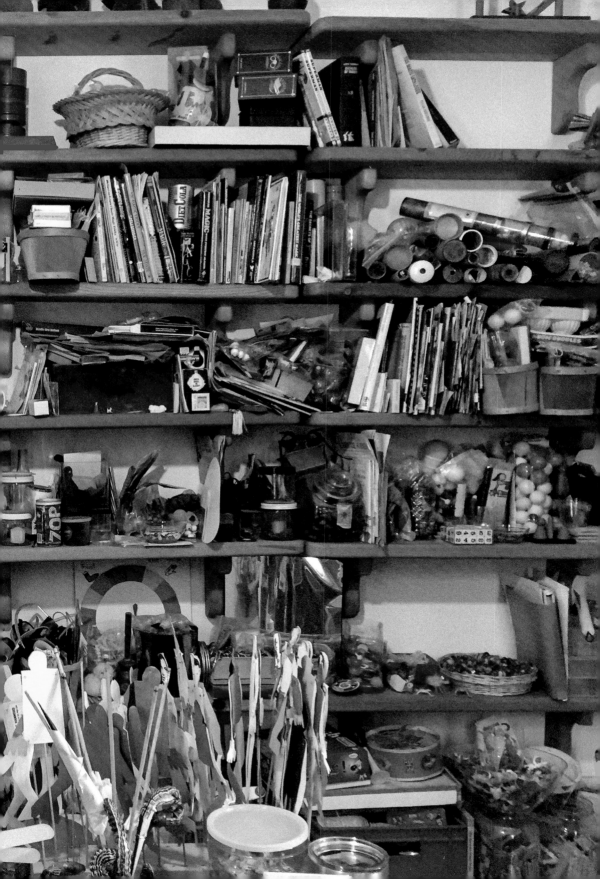

makers, pre-Columbian heads, Braille books, fossils, bird specimens, brooms, Mexican folk art, honey, eight-page books, and magic tricks.

This book is a way to capture Pat's stories while she is still alive. Pat is the family's storyteller; she is known for giving spontaneous performances as she recounts the history of a particular object. Pat's family sought to document these stories because, without Pat, much of the meaning behind her collections is lost.

However, Pat is notoriously reluctant to refer to herself as an artist. She would just as soon laugh at the idea that what she makes is art—and she is immediately suspicious of a project focused solely on her.

So Pat's family and I concocted a plan. We agreed to document the house as an excuse for documenting her art. I would meet with Pat once a week, and on each visit we would look at a different room of the house. Gradually, we created a portrait of Pat's art by moving from room to room.

I went to Pat's house once a week for nine months. Each week, I brought lunch and we sat at the kitchen table talking about her collections. Before each visit, I gave Pat a short "assignment," to think about a specific collection; I tried to give each visit a theme. One day we looked at birds' nests, another day at folk art. One afternoon we used Pat's vintage Mexican brooms to sweep leaves from the driveway. Another day we looked at the tea collection. We also spent several visits talking about bees and tasting honey.

I also interviewed Pat's immediate family. Her daughter Mills told me stories of making mud pies as a kid and how Pat taught her to make her own dresses. Her son Jeff, an Episcopal pastor, gave me a copy of Pat's Kite Sermon, as well as numerous other written works, and Pat's collections of famous aphorisms written on index cards.

The following essays present a selection of these visits. Each chapter centers on one of Pat's collections, such as pins or spinning tops. The collections interact in odd and amusing ways. Sometimes the tops would come up while we were looking at her eight-page books. Sometimes pins would come up when we were looking at fossils. The kites came up in nearly every conversation we had.

The secret of Pat's art is that she finds great meaning in ordinary things while simultaneously looking beyond their material value. She is fascinated by something she perceives below the surface, like the unseen wind that gives life to a kite—and her inquiry gives rise to unexpected insights.

This book offers a glimpse into what Pat is trying to create, a world at once magical and mundane. The stories collected here endeavor to create a portrait of Pat as a significant artist who has sought to transform each moment into a creative act.

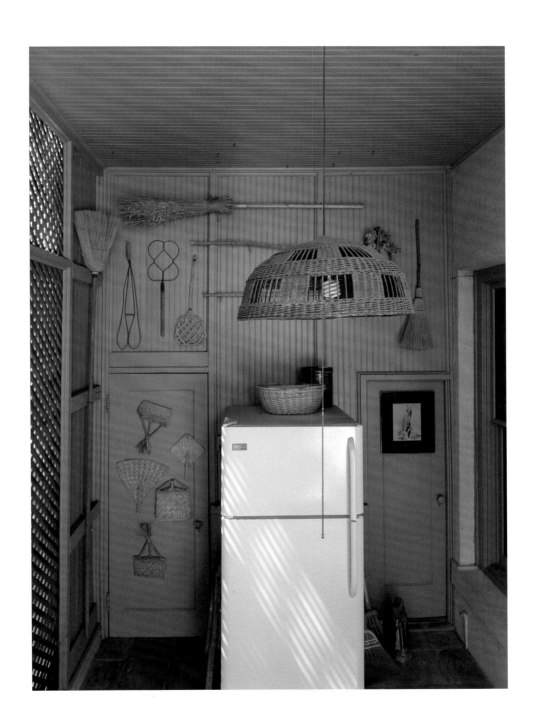

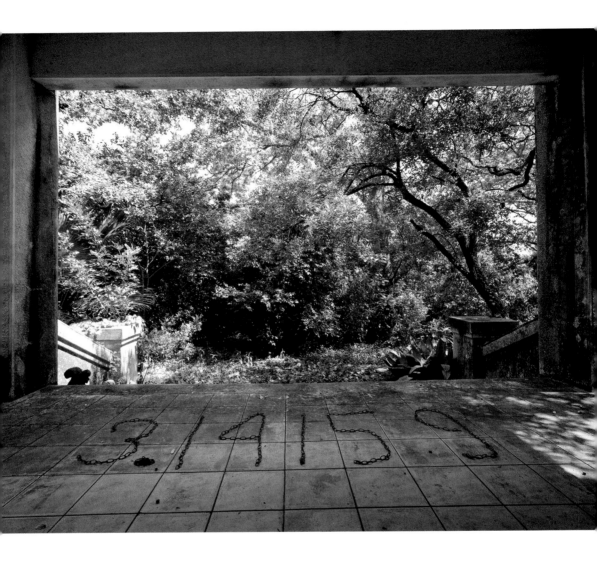

1. Re-words

Re-focus	Re-master	Relinquish	Re-adjust
Re-patriate	Re- charge	Reimburse	Re-main
Recant	Re-claim	Re-distribute	Ready
Re-new	Recognize	Re-collect	Real
Re-do	Resonate	Relax	Realize
Re-boot	Re-center	Redact	Really
Re-call	Redeem	Rebound	Rejuvenate
Re-view	Re-collect	Re-create	Re-appear
Re-mediate	Remedy	Re-generate	Reservoir
Re-gain	Recommend	Re-fund	Re-quest
Re-discover	Re-construct	Re-mark	Reflect
Re-start	Recoup	Re-act	Re-search
Re-form	Re-cover	Re-live	Re-fund
Re-fresh	Recruit	Re-align	Relative
Re-model	Re-construct	Refrain	Relieve
Re-cycle	Re-order	Relinquish	Re-enact

Above is part of a list of *re*-words compiled by Pat Hammond. It is neither definitive nor arbitrary. Rather, it is a collection of *re*-words for your perusal. *Review* them at your leisure. *Rearrange* them. *Reflect* on hidden meanings. *Remedy* any glaring omissions with a pencil. *Relax*—there won't be a quiz at the end. Instead, this essay seeks to render the work of Pat Hammond in words and images. It is not a complete portrait, but I endeavor to give you a taste of her spirit and wit. Words are often a poor substitute for reality and for so much left unspoken, but they will have to suffice.

And with Pat, there is much left unspoken. She can convey great meaning in a smile of delight. A wistful glance often implies a tangle of thoughts and connections between disparate objects and ideas, such as "bees, honey, flight, science, inductive reasoning, and spacecraft." For Pat, these connections appear simultaneously and intuitively. The leap from bees to spacecraft fascinates her. In the gap lies so much of the knowledge, history, and ideas that she has gathered over time. By acknowledging these connections, she also recognizes the limits of language.

But we shall forgive the words their shortcomings, for there is much to convey, and Pat's love of the written word is as voluminous as the above list of *re*-words implies. Pat sees adventure in these *re*-words, for

their prefix suggests that you will return again and again. And you might find something different each time you do.

The pleasure to be found in words is perhaps one of the first things you recognize when meeting Pat. She loves puns. In fact, when you first walk up the steps to her home in San Antonio, Texas, across a shaded walkway of giant oaks, loquat, and laurel trees, you come upon a series of stone lambs placed upon each step: a lambscape.

This kind of word mischief appears throughout the house: *Problems? Please inform our staff* (written on a note card next to a wooden staff). *Our wish has not been granite* (above a countertop covered in tin). On the kitchen counter, there is a small collection of objects: a bowl of honey next to a container of toothpicks; six matchsticks delicately balancing on the head of a seventh; a series of paper tables. One paper table has the words NEGOTIATING TABLE written around the top. Beside it there is a small bowl of arrowheads labeled IMPORTANT POINTS.

At the very entrance to the Hammond home, sitting outside the main door, is a container filled with old metal chains. Pat usually welcomes her guests by spelling out a letter with chains at the front door: a chain letter. The chains often spell the initials of the person who is coming to visit. The first time I interviewed Pat, however—four years ago—the chains spelled numbers instead of letters. It spelled 314159265. Pat urged me to solve the riddle. "It's easy as pie," she said. It took me a moment, but I soon realized that the numbers spelled out the mathematical symbol π; she'd been inspired by the date, which happened to be 3/14.

"I say two things in the morning that remind me why I am grateful for being alive," said Pat. "I can remember the speed of light, which is 186,000 miles per second. And I can remember pi to the ninth place. At the age of seventy-eight, I may have forgotten many things, but as long as I can remember the speed of light and pi, I know I am still okay!"

At the time, I interpreted this as Pat's quirky humor and as a fun mental exercise. Her recollection of pi and the speed of light were reminders of important things—i.e., infinity, and the human capacity to grasp qualities of the infinite through inductive reasoning. But I later realized that these mind games also served as a very real test of Pat's memory, a kind of daily diagnostic check for signs of dementia. Pat was probably aware of the dementia early on, long before it was officially diagnosed.

Today it is affecting her ability to remember things that just happened. Her long-term memory is still very sharp and clear. She can hold a normal conversation—and she can, as she said, even recite pi to the ninth place. But Pat is losing her short-term memory. This is part of her current reality, and she is very much attuned to it.

Pat's use of something seemingly entertaining to convey something serious is a pattern that repeats itself in conversations with her. This playfulness is the trick, the illusion that brings you closer to an essential truth.

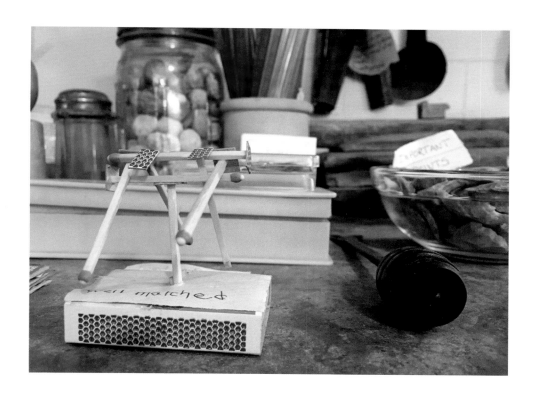

"Sometimes people might overlook that I am talking about something serious with kites," she said, referring to her extensive kite collection, which she often used to teach kids about science, innovation, and physics. To Pat, the kite is an allegory for human life. Just as a kite is made from sticks and paper, and animated by air, we are made of skin and bones, animated by breath and spirit. But the kite is also a toy. It is at once serious and whimsical.

Pat's Artistic Process: Repetition

Though Pat does not consider herself an artist, the objects that she has carefully collected and assembled in her house, the fragile beauty of the cicada shells she has collected in jars, even the very words she chooses to write or speak, reflect an artistic sensibility and method. The acts of selection and arrangement require ingenuity, patience, and discipline. Ultimately, she has created meaning among ordinary things.

And repetition is a fundamental part of her process. She doesn't merely like the sound of re-words; she likes repeating things. To re-discover, to re-create, to re-cognize, implies that once is not enough. The idea of doing something again and again, of coming back around, is important to her. Seeing objects more than once is a way of not taking them for granted, of gaining new perspective. "Re-spect," Pat puts it, "like spectacle. We have to see it a second time."

Repetition is also the unspoken rule of Pat's collections. She creates or gathers multiples of everything. There are dozens of tops, dozens of pins, dozens—no, hundreds—of eight-page books (made from a single piece of paper, folded four times and cut in the middle, to create a miniature book), and hundreds of kites.

Pat also has a series of "window treatments," made of hundreds of hanging lollipops (treatments), and there are dozens more at the Hammond farm in Blanco, Texas.

In the back living room of Pat's home, there is a wall containing the last remnants of an old magic shop that once existed on Broadway in San Antonio. It was owned by an old man and filled with troves of multiple magic tricks: hundreds of miniature squirt guns, a bowl of smoking lambs (if you stick a rolled-up piece of paper in its mouth, each little lamb will puff smoke rings), a cookie jar full of fake mustaches, a couple dozen exploding balls, and a dozen trick snakes. Pat bought everything.

Across the room there is a box of small wooden men. She had a carpenter cut out hundreds of them, which her children and grandchildren would line up domino-style before tipping the first one, causing one small man after the other to fall all the way through the house.

Upstairs, she keeps collections of animal specimens, including bird wings, reptile skeletons, butterflies, beetles, and a rare weaver bird's nest.

the seamless

A 2015 work by R. H. Q

of withdrawal or a combined

Pat not only collects multiples of the same kind of object; she also produces multiples of her own work for distribution. With her photocopier and printer, Pat is her own printing press, churning out numerous copies of her eight-page books, some of which may feature revised editions. She gives these away to her friends and visitors.

Pat's abundant generosity is often expressed in this way—she gives away small presents that are playful and illuminating. Once Pat gave me a small container of Mexican jumping beans with an eight-page book called *The Bean Counter*. She also gave me a scriber for etching secret messages onto glass. (If you're ever in Pat's home, take a close look at the glass windows for secret messages.)

Once Pat gave me a Ping-Pong ball with an open circuit (there's a battery inside); you close the circuit and make the ball light up by holding someone's hand. She used this ball to teach elementary school kids about electrical current. She would arrange over a dozen kids in a circle holding hands. Once everyone in the circle was touching, she would place the ball between any two children. If the child on one side touched the positive connector with his right hand, and the other child touched the negative connector with her left, then the light would turn on. In this way, Pat taught them that electricity is dependent on multiple connections in order to function. It won't work if there is only one hand touching the Ping-Pong ball.

Learning from Repetition

Repetition promotes learning. By going back to her words and puns, Pat is refining her skills as a wordsmith. She is constantly sussing out words in her mind for hidden meanings and connections; she is summoning the otherwise hidden or obscure. In fact, Pat once made a pin out of paper with the word "suss" cut from it—as in "sussed out." Likewise, for her timepieces Pat replaces the numbers on a clock with words or phrases— she challenges herself to find twelve-letter words or phrases that relate to time. She has, in fact, created *dozens* of them, such as *All Out of Time*, or *Wonders o' Time*. Sometimes, the title of the clock is also a pun—like *One's upon a Time*, for a clock with a face made up of twelve 1's.

Repetition also provides structure and routine. This is perhaps another reason Pat adheres to it: There is safety in it. The habit of making an eight-page book everyday is comforting as well as stimulating. Instead of doing a crossword puzzle or Sudoku, Pat makes an eight-page book.

This is true of Pat's stories as well. When she is engaged in conversation, she will often repeat the same story about a particular object, but with a liveliness that feels as if she is telling it for the first time. It is almost like she is reliving the experience through the retelling. Perhaps

the reason she can remember so many quotes from so many sources is that she comes back to them again and again. She is verbally underlining these things the same way she underlines important passages in books.

Even with the discovery of her dementia—and even though she struggles sometimes to follow the thread of a conversation— Pat returns to her lists of words and puns and collections. *Re*-words imply that more work is needed here. Each repetition is a chance to suss out new meanings and rediscover important things.

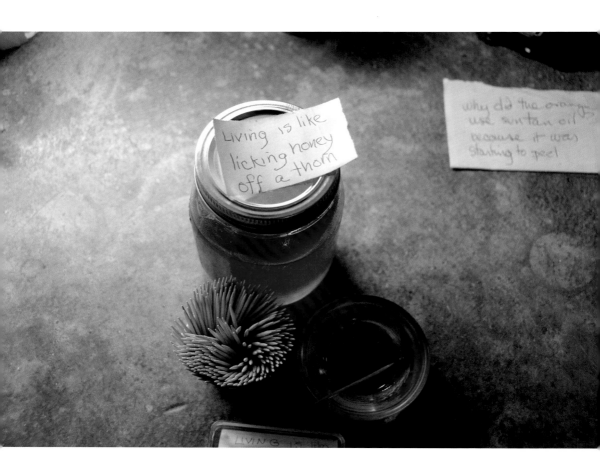

2. Bee Brain

Bee! I'm expecting you!
Was saying Yesterday
To Somebody you know
that you were due—

The Frogs got Home last Week—
Are settled, and at work—
Birds, mostly back—
the clover warm and thick—

You'll get my Letter by
The seventeenth; Reply
Or better, be with me—
Yours, Fly.

—Emily Dickinson, no. 1035

When Pat's son Robert was young, he had difficulty reading. He loved *being read to*, but he refused to read on his own. This became a problem when he started elementary school. "We knew he was bright," says Pat. "But the teachers didn't cut him any slack—I mean, he couldn't read. I just didn't know what to do. He was seven."

Pat took Robert to a psychologist. The psychologist said it might be a neurological problem but could also be something much simpler. He suggested that perhaps Robert wasn't reading because he had no incentive to read: He was the baby of the family, so there were simply too many people willing to do it for him. The psychologist recommended that everyone stop reading to Robert—at least for a time—to see if this would encourage him to pick up a book by himself.

Pat agonized over the decision. She worried that it would seem cruel, suddenly withdrawing this ritual from his life. When she finally broke the news to Robert that he had to read on his own, she offered a surprise incentive to sweeten the deal. "I said, 'We will do something really fun when you read your first book'"—though she had no idea what that would be.

To her surprise, it worked. Robert read his first book, an alphabet book called *C D B!* by William Steig, which offers letters as codes. In other words, *C D B!* is *See the Bee!*

"It was a pitiful little thing with a picture of a bee on the cover," recalls Pat. "He read it and then said, 'What's my surprise?' And I said, 'We're going to get a beehive!'"

Bees are one of Pat's obsessions. When she talks about "the bees," as she often does, she is referring to a period in her life when she was an amateur apiarist; she kept a live beehive in her upstairs living room for fifteen years. She bought the bees from a professional beekeeper in Navasota, Texas. She did not keep the bees to sell honey, although she did collect it. Instead, she and her family simply liked to observe them.

I come over to Pat's house one afternoon. I arrive in her kitchen to find a collection of notes, newspaper clippings, and books about bees alongside a bowl of honey. I sift through a stack of index cards on the table, each one containing a different note about bees. The first card says, "One ounce of honey comes from two hundred thousand trips. One pound of honey means circling the globe three times." Another offers a quote from Virgil's *Georgics*: "Such rage of honey in their bosom beats, And such a zeal they have for flow'ry sweets."

The array of items on the table is an interesting mix of science and poetry. Several of the facts are remarkable, such as "A single bee can fly 1,250 miles." Some of the poems are funny, while others are philosophical. I cannot tell if Pat wants to talk about the science of beekeeping or the writings of Virgil, who once said of bees, "Their little bodies lodge a mighty soul."

When the bees came into Pat's life—seemingly at random *and* by will—she pursued them with her boundless energy and curiosity. She learned everything that she could about them. She admires them for their passion, discipline, and hard work as well as their otherworldly powers.

"The bee provides everything," says Pat. "Stories galore about bees. The sting, for example—it is powerful, in terms of communication. Just about anything you can think of, the bees are a good way to teach it."

That is the other draw for Pat. She loves to impart the bees' lessons, although she doesn't do it in a didactic way. She can tell stories about them, relate stunning facts and intriguing quotes, without ever giving a sense that she is also teaching.

She is even able to offer her guests a sumptuous delicacy as she illustrates the bees' abilities. Pat keeps row after row of jars of honey at the top of her fridge—and some of it is actually honey that she collected from her own bees fifteen years ago. She pulls two jars down and picks up a toothpick. She dips it into the first jar and then sticks it into her mouth. Her face lights up. She urges me to try.

I pick up a toothpick, dip it in the first jar, and put it in my mouth.

"You have to hold your nose," she says. "Now roll it round. It's like sipping wine."

I press my tongue against the toothpick, and the flavor fills my mouth. "It is fruity."

"Now try the other one. See, this is guajillo [pronounced wah-*he*-o] honey." Pat holds up a jar of dark amber. I taste it. It is like no other honey I've tried before—it's richer and leaves an earthy aftertaste. She looks at me expectantly, thrilled to have introduced me to this new sensation. This is something she will do time and again during our visits. She will bring down her jars of honey, offer me a toothpick, and wait for me to react. And each time she will repeat her favorite phrase: "Life is like licking honey from a thorn."

After Pat promised Robert the beehive, she ordered a frame. It was a little more than a foot tall by a foot long, and four inches wide. The side of the frame was made of glass so that they could see inside. She installed it in their upstairs sitting room and connected it through a tube to a small opening on the windowsill so the bees could fly in and out.

She drove to Navasota, Texas, herself to pick up the beehive. "I brought the frame and drove home with a hundred bees in it in the car, thinking, 'I'd better not have an accident.'"

The queen bee arrived separately by mail in a small wooden box marked "Deliver Immediately: Bees." This box had a tiny screen to let in air, and inside, along with the queen bee, there was a candy plug—a small stopper made of sugar. Pat often tells tall tales, and at first I thought this was one of them. But I did my own research on the Internet and, lo and behold, there were images of small wooden boxes with screens and express mail envelopes with LIVE QUEEN BEE stickers on them.

Before a new queen can be brought into a hive, the beekeeper must first introduce the queen to the hive in a particular way: "gradually," says Pat, "otherwise they could kill her." The beekeeper does this by placing the caged queen—with the candy plug facing out of her door—next to the entrance of the hive. By the time the bees have eaten through the candy plug, usually a couple of days, they will have become accustomed to the queen's scent and will welcome her into the hive.

Many nights, Pat sat reading on the couch and listened to the sound of the bees. "When the hive was alive," she says, "there was a very faint wonderful sound of the most low-frequency buzz that was just like a chorus—it was barely audible."

After lunch, Pat and I go upstairs to see the old beehive. It stands on the same table in Pat's living room when it was filled with the soft hum of hundreds of bees. It is empty now. Pat still keeps a photograph of a beehive inside the empty frame as a reminder of what it once looked like.

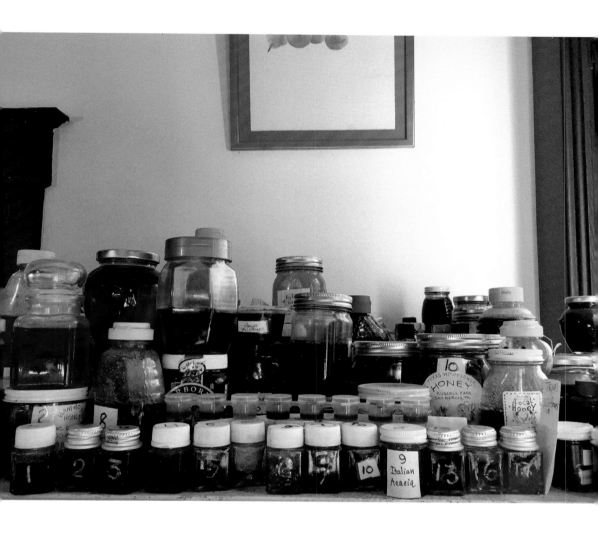

Teaching Bees

Later Pat sometimes closed the latch on the beehive and took it to her grandchildren's school to teach a class about bees. Pat never taught formally, but she often gave impromptu lessons on science. She was a natural teacher, and the hive was an instant crowd-pleaser. Most kids had never seen anything like Pat and her beehive before.

On each visit, she brought honey samples for the kids to taste. And she told stories about its chemical properties, like the story of Lord Carnarvon and the discovery of the tomb of Tutankhamen.

Lord Carnarvon traveled to Egypt to see inside the tombs of the Pharaohs. "However, there was a huge controversy," says Pat. England had conquered Egypt. The discovery of Tutankhamen's tomb was politically charged because it meant opening holy tombs.

"Lord Carnarvon was the first one to get a peek inside. And there were all of these people behind him, saying, 'What do you see? What do you see?' And he said—'Wonderful things!'"

In the tomb, they discovered jars filled with honey. The honey contained the organs of the dead. The organs were perfectly preserved, *and* the honey was still good. "It may not sound appetizing," says Pat, "but it tells you about the chemistry: Bacteria cannot grow in honey."

"Were the Egyptian bodies still fleshy?" I ask.

"They cut out the heart and they cut out the organs. I don't know. I am not reliable. I will tell you when I make things up and when there is a thread of truth attached to it."

Pat's stories might not all be 100 percent accurate—but that's okay. She always remembers the point even if she embellishes the details. The important thing is to get the lesson across—which, to Pat, means not simply stating facts but transmitting the wonder and excitement that can, and should, be drawn from the world.

Pat gained most of her knowledge about bees by reading works by Karl Von Frisch. He won a Nobel Prize for Physiology or Medicine in 1973, along with Nikolaas Tinbergen and Konrad Lorenz, for his research decoding the language of bees and pioneering the science of ethology, the objective study of animal behavior as an evolutionary adaptive trait.

Pat admires the simplicity of Von Frisch's experiments; they were easy enough for a child to understand, yet sophisticated enough to decode an entire hidden system of language among bees. Von Frisch also had the rare ability to communicate his discoveries and his process in layman's terms, a trait that Pat admires all the more because of her own unpretentious style of teaching.

Von Frisch's most fascinating discovery is that bees communicate through dance. With certain movements, a bee can communicate complex information to its hive about the distance, direction, quantity, and

color of nearby flowers. A bee can even relate the exact coordinates of a flower up to six miles away.

One crucial element of the dance is the intensity of the waggle. A fierce waggle indicates a flower that is a great distance from the hive; a more subdued waggle indicates a flower closer by.

"It is language!" says Pat. She compares bee dancing to ballet or the Texas two-step.

Von Frisch's work reveals that bees have consciousness; this fascinates Pat. Bees make group decisions. They build complex societies with a social organization. They are models of efficiency and cooperation—and without them human agriculture would not be possible.

Furthermore, Von Frisch suggests that the boundaries of human understanding are simply that—human.

"To be called a 'bee brain' is so derogative," says Pat, referring to the playground taunt she heard as a child. "But to be compared to a bee is really an extreme compliment."

Before I leave, Pat shares one more story with me, about a bee and a wasp.

> One day, a wasp turns to a bee and says, "We both have stingers, but people love you and hate me. What is your secret?" The bee responds, "If you want people to love you, you have to give them honey."

With the bees, Pat found a fun way to teach abstract ideas: discovery through the scientific method, ecological interdependence, community organization, and communication through visual language.

She understands the science better than most, yet she doesn't claim to be a scientist or a teacher. She is even slightly ambivalent about calling herself a beekeeper: "I just kind of fell into it — I really hoped it would be a way to get Robert to read."

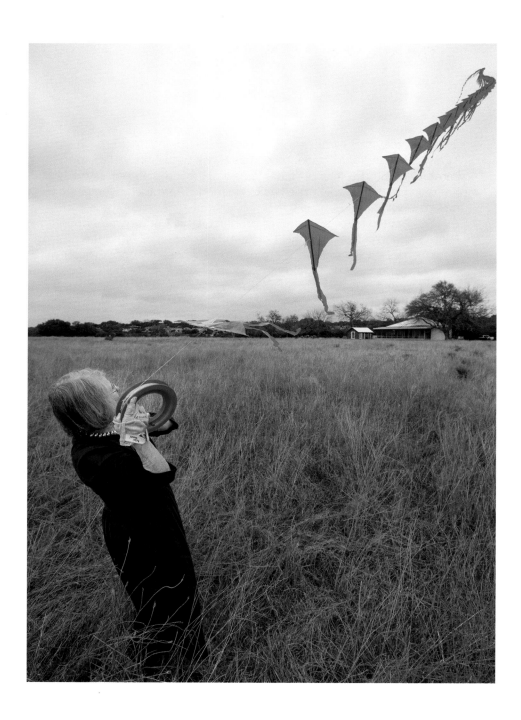

3. The Kite Lady

On a Saturday night, I drive the winding road from Wimberly to Blanco, Texas. I arrive early to inspect the kites in the barn. This is Pat's most carefully curated collection: It contains antique kites, as well as many of her own creations, which she has exhibited in more than twenty museums and galleries.

The Blanco River crosses this property, a Hill Country farm bought by Pat's husband's parents in the 1940s. A dirt road leads up to the house from the river, lined with giant live oak trees whose branches reach so far they nearly touch the ground. When I arrive at Pat's farmhouse, at the top of this road, I see that it opens onto a field of wildflowers. I think about Pat's surroundings, about how they are at odds with each other—that is, despite the accumulation in her home in San Antonio, the tumble of small objects and teetering piles of paper, the natural world around her always seems to insist on its elegance. And here in Blanco, Pat brings this inside; her house is a surprisingly stark canvas—empty white walls and bare tin counters—against which she has displayed minimal statements from the outside world. A bird's nest is prominent in her starkly furnished living room, and two white pom-pom-shaped seeds—from the milkweed plants that line her property—sit by themselves, like two clouds, on her kitchen counter.

I pull into the driveway. The sky is turning pink. I grab a flashlight and head down to the barn. It is red, with a gambrel roof; inside, it is old and musty. I know that no one has touched these kites in a very long time. Pat has warned me to expect the worst.

I have been mildly amused by these warnings; Pat has a habit of lowering expectations only to reveal something wonderful. I imagine the barn as loaded with giant crates stacked to the ceiling, each filled with rare and delicate kites.

But when I shine the beam of my flashlight into the barn, I discover the kites stashed away in crumbling cardboard boxes piled five feet high. One entire column has fallen, scattering half-open boxes on the floor. And in the dim light I can see that the boxes are covered in dust and wasps' nests and mouse droppings. There is also a sickening sweet smell, like that of a rotting corpse. Pat's husband, Hall, had mentioned to me earlier in the week that a cat had died in the barn—I guess he'd wanted to warn me of the stench. But this is so much worse than I'd anticipated. The smell makes the decay of the boxes seem that much more desperate. I am doubled over, holding my nose, trying not to retch.

The sight of so many kites eaten away by bugs makes me feel sad—and it makes this endeavor feel hopeless.

Even with the front door to the barn open, it's hard to breathe. I try to open a window, but I cannot find one—there are none, as it turns out. Instead I discover a second door leading to the outside, and I open that too to let in fresh air. There are several other half-doors, which are latched from the outside. I run outside and open them. It brings some relief.

I go back outside and phone Heather Snow-Fulton, a registrar at the San Antonio Museum of Art. She and Pat are old friends; it was Heather who first introduced me to Pat in 2008. (We worked together at a perennially underfunded Latin American art museum in San Antonio.) She is also meant to come the next day to help me document the kite collection.

I tell Heather about the circumstances—the boxes covered in mouse shit, the stench of dead animal, the dilapidated state of it all—and she talks me down. She also offers a plan: We will pick out six boxes that look promising and document them, then save the rest for a later date. Today I need only pick out the boxes that seem interesting.

I go back into the barn with renewed purpose. I pull out two boxes labeled ASIAN KITES. Inside one, I find a beautiful dragonfly kite eaten by moths. When I pick it up, the wings of the dragonfly rip away from the frame. I open another box and discover a pile of nylon kites—less exotic than the dragonfly kite, but these are in surprisingly good condition. I set those aside too. Finally, I uncover a large box labeled GUATEMALAN KITES. These are the very kites that brought me to Pat in the first place, and I know from our early conversations that they are the gems of her collection.

These kites are wrapped in a pristine sheet of heavy plastic. I pull out the first Guatemalan kite. Its edges are slightly frayed, but the center is largely intact. The patterns are heart-shaped. I suspect Pat made this one. I pull out a second kite. It's in excellent condition, about thirty feet wide and made up of brightly colored geometric shapes. It is rare to find a giant Guatemalan kite like this outside the country—partly because, until the late 1970s, the kites were burned after the Day of the Dead festival, but also because the kites came to be considered serious works of art and were not typically sold. (Later Pat told me she bought this particular kite in the 1970s, from a family who made it together in Santiago, Sacatepéquez.)

I am amazed that these kites have survived the decades in the barn. But I also realize that the preservation of this collection—to the extent that there is preservation—is basically an accident. The kites were sent back from the various museums and galleries where they'd been shown—some packed more carefully than others, some in wooden containers, some in plastic—and then were stashed here

for decades. I suspect this is the first time they've been opened since. Pat never really meant for any of these kites to be maintained—in fact, she'd thought about burning them all. She'd gotten this idea from the Guatemalan kite makers who would fly their kites on the Day of the Dead and then burn them the next day as an offering to the spirits. But this letting go is also an essential part of Pat's nature: As passionate as she is, she is not attached.

The Flying Contest

Pat is known in San Antonio as the "Kite Lady." This moniker was pulled from an article, one of many, that ran after her collection of kites started to make the rounds at museums and art galleries, first locally and then nationally.

But Pat's career as the Kite Lady truly began with a single unexpected achievement: On April 1, 1972—April Fool's Day, as Pat is quick to point out—she won the Smithsonian National Kite Flying Contest. At the time, Pat knew very little about kites. In fact, before winning the Smithsonian contest she had only flown a kite a couple of times. A friend had given her a delta-wing kite from Nantucket, and she'd liked it enough to try to make one of her own. Later that year, Pat entered the kite competition on a lark. Her husband had seen an advertisement for the competition in the *Smithsonian* magazine and had encouraged his wife to enter. At the time, Hall traveled a lot for work; he wanted Pat to take a trip of her own.

When she arrived in Washington for the competition, Pat felt like an exotic bird compared to the other contestants. The others were "serious hobbyists," retired air force officers and scientists—and Pat was the only woman in the competition.

Nonetheless, Pat enjoyed herself. She had made her own kite, with the help of a designer in Austin, and named it *Red Tails on the Sunset*. It had a picture of a setting sun that coincidentally looked like the emblem of the Smithsonian.

On the day of the competition, Pat took her kite to the National Mall. "It was this glorious day," she recalls. "And I just walked into the national competition. I didn't know what I was doing, but I was having a ball!"

The judges took her out on the field. Each contestant had one opportunity to fly a kite. The head judge told Pat, "You may choose where you want to launch it." Pat said, "This is fine."

"I only had to punch one button," Pat remembers; she'd used a deep-sea fishing reel for the line and had designed it so that she need only touch one button in order to achieve liftoff. Pat's kite soared into the air—"just like someone was pulling it," she said.

Afterward, the judge took Pat's kite and laid it out on the grass.

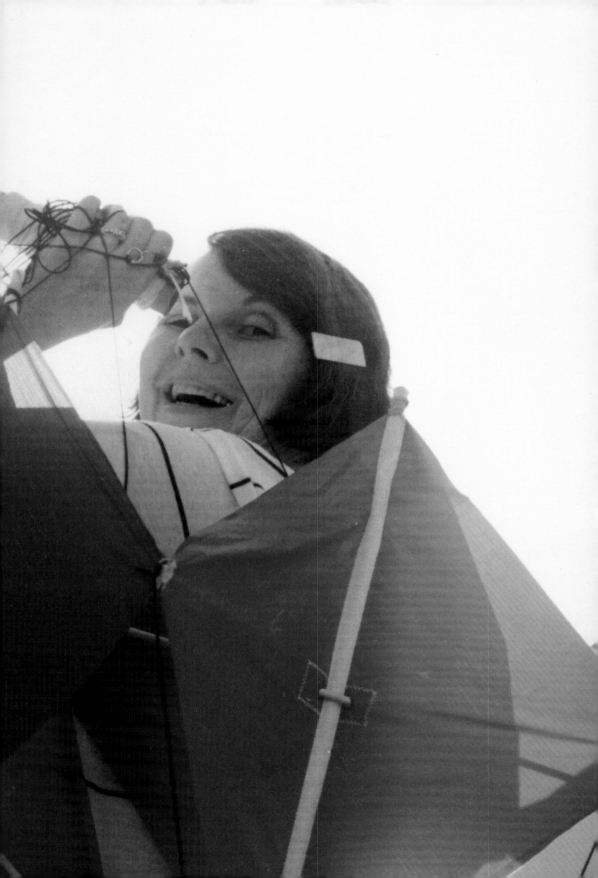

He walked around it, studying the design. He picked the kite up, handed it back to Pat, and said, "That was a very nice flight." She smiled and thought, *You are a very nice man to say that to me!*

Pat stuck around to see the rest of the competition, accompanied by a small group of friends from D.C. and Philadelphia. The other kites at the festival were spectacular. One was in the shape of a cloud. Another was in the form of an eagle whose wings could really move.

At the end of the day, the head of the Smithsonian arrived on the stage to announce the winners. When telling the story, Pat puckers her lips in imitation of this man and says in a surly voice: "We hear—a great deal—about Women's—Liberation . . ."

At the mention of "Women's Lib," Pat and her friends screamed and hollered—they knew he could only be referring to the lone woman in the competition.

"After I went up to get the trophy," Pat recalls, "we went back to the Hay Adams—this fabulous old hotel—very staid. We came in, happy and celebrating. That hotel changed from being staid . . . I mean, I had people coming to the hotel asking, 'Can we see?'"

She called her family to tell them that she had won. They thought it was an April Fool's joke.

When she returned to San Antonio, family and friends greeted her at the airport. They carried funny signs to toast Pat's unexpected victory. One read, "Sic Transit Gloria," Latin for "Thus passes the glory." Another said, "Lift over drag—frankly, we never thought you could lift your drag." Another asked: "Who's Mr. Ju?" (Mr. Ju had won the year before. "He knew all about Chinese kites," Pat explains. "He was *it*.")

"It was such a gift—an improbable, unearned gift," says Pat. "I didn't win because I had worked hard, studied, read, or learned. It was totally gratuitous."

But others' interest in her kites continued—and, concurrently, so too did Pat's. Once back in San Antonio, she began to create more kites of her own. In 1974, a woman putting together an exhibition at a local San Antonio gallery called The Bright Shawl asked Pat if she could include some of her kites. A few years after that, Pat was invited to show her kites at the newly constructed University of Texas Health Science Center. Pat hung her kites in the atrium, wrote text panels, and printed a small catalogue describing each one. She titled the exhibition *The Kite: More Than Meets the Sky*.

After that, Pat began to display her kites at museums across Texas: She had exhibitions at the Laguna Gloria Art Museum in Austin, the Dallas Museum of Art, the Art Museum of South Texas in Corpus Christi, and the Rosenberg Library in Galveston.

The newspaper headlines from this period, as I mentioned, gave rise to Pat's "Kite Lady" persona:

Exhibit up in the air: "Kite Lady" to be featured at Witte Museum
—*Express News*, 1987

Giving shape to the sky: Pat Hammond releases stunning kite collection to the wind
—*San Antonio Light*, 1987

The Kite Lady: "For heavens sake, go fly a kite!"
—Sunday Magazine, *Dallas Times Herald*, 1979

Introducing her high-ness, Pat Hammond, the kite queen
—*Communications Update*, 1982

This led to inquiries from museums across the country. Throughout the 1980s, Pat traveled with her kites to Virginia, Philadelphia (where she was commissioned to make a large delta-wing kite for the Children's Hospital's five-story atrium), and Washington. In 1980, the Smithsonian acquired a bird kite made by Pat and put it in their National Fine Arts Collection. Finally, in 1991, the Museum of Modern Art curated a group exhibition called *Zero Gravity*, which included a number of Pat's kites.

These exhibitions forced Pat to shape her ideas about kites into a narrative, something she'd never had to do with any of her other collections. The beauty and success of the exhibitions is that Pat did not simply treat the kite as an art object; rather, she sought to express the joy that comes from the experience of flying a kite.

She insisted on designing and installing each exhibit herself. She included kites from Guatemala, Korea, and Polynesia, all cultures where the kite is revered as an intermediary to heaven—and she showcased her own designs as well. She displayed replicas of the famous Cody "man-lifter" kites—a double box kite designed to lift a person from the ground—and Alexander Graham Bell's tetrahedrals, with four triangular sides, scaled to fit a man and a motor, which ultimately gave rise to aviation and space flight.

She evoked a sense of mystery by hanging the kites in midair and at a slight angle, which prompted them to move slightly every time the doors to the museum opened or closed and brought a gust of air.

"You still hear people say, 'I wish I could fly like a bird—soar, glide, sail, be free,'" wrote one reporter. "The exhibit doesn't preach this message, but you can't miss it. The kite is lifeless until it reaches the breath of the wind—the unseen, the invisible."

In fact, the invisible—not only the wind but also the palpable sense of spirit—was at the heart of Pat's obsession. "Everything is potentially more," she wrote in the catalogue for her exhibit, "even the thin, fragile, almost invisible string—the tension of the string, connecting the kite to

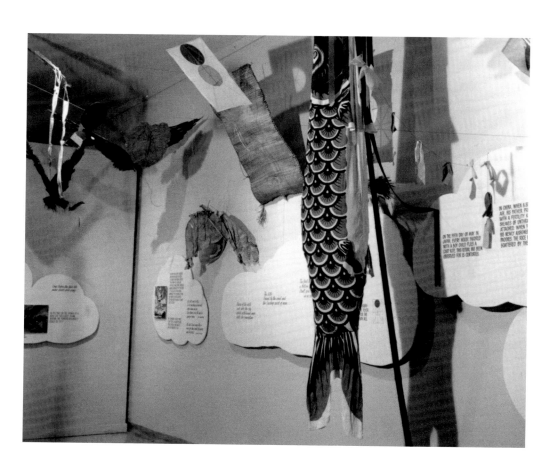

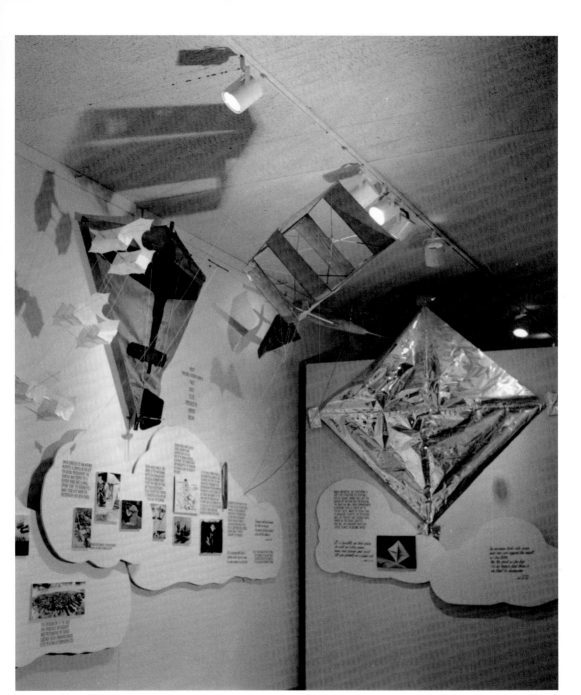

the earth gives freedom to go up or down, to hold fast or steady . . . Like the kite, we resist tension and yet we thrive on it—the 'string,' the reality of opposing forces in life compels us to grow, to struggle, to be more."

Uncovering the Kite Collection

In the morning, Heather arrives and we head down to the barn. Even with the windows left open overnight, the scent of the dead cat lingers. We load six boxes onto a wheelbarrow and wheel them up to the main house so we can escape the smell.

We put on our gloves and take the kites out one by one. First we look at the Asian kites. One has a beautiful print of a Japanese lady holding a paper fan and standing in front of a house beside the ocean. Then there is a red dragon, which is actually a chain of several kites with the face of a dragon at the front. Another kite has the face of a cobra and a long black tail. I pull out a beautiful Japanese kite in the shape of a deep blue owl.

At the very bottom, we uncover a giant Japanese koi or carp windsock. On Boy's Day, as Pat described it in one of her exhibition catalogues, every house in Japan blessed with a son flies a carp from the rooftop. Fathers tell their sons how the carp "resolutely overcomes all of the difficulties it encounters—a near impossible journey up the steep mountain streams, ascending waterfalls, swimming over glass-sharp rocks." The mythic belief is that once the carp surmounts all of these difficulties, it is transformed into a flying dragon.

We open another box. This one has a dozen butterfly kites from India. Some of them are pink and green. There is a beautiful moth kite with long tails and bright eyes.

These first two boxes alone hint at the great variety of Pat's collection. She collected multiples of kites she loved. And yet all of the boxes in the barn only represent a small fraction of Pat's entire collection.

Many of Pat's kites are conceptual; that is, they exist only as an idea or a sketch or a quote. Pat didn't actually end up making them or flying them; she just enjoyed the opportunity for creativity and whimsy. What Pat really loved to do was to dream up names for these kites. In fact, the kite, in and of itself, wasn't the point; she became much more interested in what it represented.

The best example of these "conceptual kites" appears in the catalogue she created for the exhibitions. At the end of this catalogue is a booklet titled *The Book of Common Air, a Highly Irreverent Collection of Kites, Together with Kitechism, Pat Hammond's theory of aerodynamics: NAME THEM—THEY FLY BETTER*.

There is *Saph Higher Blew*, a sapphire blue kite; a kite in the shape of a bedpost, called *Bed Soar*; a kite in the shape of the Alamo called

Alamo Heights or *The Fall of the Alamo*, depending on the experience; a kite made of five-dollar bills named *High Fives*; and a kite that displays a drawing of her family, which she calls *Raising a Family*.

In the pamphlet, each kite is hand drawn; the kite's thread and bridle link it to its name, which is handwritten at the bottom of the page. There are eleven kites in all. Each one is simple, funny, and beautifully sketched.

Kitechism is only one example of Pat's interest in the kite as a gesture or metaphor. Throughout this pamphlet, and throughout the period she was collecting, she gathered quotes that expressed her sense of the significance of kites. "We ought to fly away from earth to heaven as quickly as we can," Plato once said, "and to fly away is to become like God, as far as this is possible, and to become like him is to become holy, just, and wise."

A Sermon on Lift vs. Drag

A year after Pat won the Smithsonian kite competition, she was asked to give a sermon on kites at the University Presbyterian Church by the minister at her son Robert's preschool.

Initially, Pat demurred. She'd received some publicity about the kites after winning the competition. Most notably, an article about Pat had appeared on the front page of the *Wall Street Journal*. She had marveled at the unexpected attention, but she did not think it qualified her to serve as an expert on kites, much less to give a sermon.

Yet after she won the competition, Pat's knowledge of kites had grown exponentially. She had read as many books about kites as she could get her hands on. She'd learned about the physics of aerodynamics. She'd researched the history of aviation and the Wright brothers. She'd become fascinated by Benjamin Franklin and Alexander Graham Bell—each had used kites in their discoveries, respectively, of electricity and in the creation of flying machines. In her search, she'd discovered the physical forces that enable flight, namely, *lift*, *weight*, *thrust*, and *drag*. She discovered that objects in flight take advantage of Bernoulli's principle, which states that an increase in the velocity of a liquid or gas is accompanied by a decrease in pressure. This means that the pressure of a gas decreases as the gas moves faster. This principle, along with Newton's second and third laws, explain the mechanisms that allow for the flight of a bird, an airplane, or a kite.

Pat describes flight as "lift over drag," meaning the forces lifting up a kite must be greater than the forces pulling it down. These forces must be in balance to sustain flight. If there is too much drag, the kite won't get off the ground. If there is too much lift, it will spin out of control.

As she studied, Pat grew fascinated by the stories—of science, physics, and flight—bound up in a kite. And she had discovered an equally

compelling story of human aspiration—of longing for flight and reaching for heaven—which led to experimentation, failure, and ultimately success.

In the end, it was this narrative that compelled Pat to give a sermon on kites at the University Presbyterian Church.

In her first sermon—"first" because she would go on to speak publicly in this way many more times—Pat offered the kite as a metaphor for human life. The kite is always caught between hope and despair. The beauty and thrill, as she'd pointed out in her catalogue, is found in the tension between the opposing forces. Flight requires balance.

The kite too was simple in its construction, yet presented great complexity. In many languages the sail of a kite is called a "skin" and the wooden spars are called "bones." "That's all we are," Pat likes to say, "a sack of bones and hank of hair."

In her writing for the exhibitions, Pat often used the kite as an allegory for the soul, but she refrained from making this connection explicit. Yet when I read the first version of the sermon she wrote for the University Presbyterian Church—a twenty-page draft that was ultimately winnowed to three pages—I discovered that Pat had made an unequivocal attempt to surface her spiritual beliefs.

In her first draft of the sermon, there is a particularly powerful passage:

KITE—Inanimate collection of sticks. strings—paper
GIVEN LIFE! Is the kite a symbol of man's SOUL?
Made of crude materials of EARTH
BONE—BLOOD. CELL. A HANK OF HAIR.
We can reduce the human body to its chemical components
BUT THAT WHICH IS MOST HUMAN IS
LOST IN THE ANALYZED ASHES!

This rant—against being too rational, against having a materialistic, godless view of the world—seemed to articulate a passionate belief.

Yet in the final sermon, I discover that Pat edited out the last four lines of this passage entirely, ending instead with the question about whether the kite is a symbol of man's soul. She then altered—and broadened—the question, changing it to "Is the kite a symbol of man or man's soul?"

As I read further, I came to understand that Pat had struck most of the explicit religious sentiments of her early sermon; the final three pages only refer opaquely to a quote from Genesis and the kite "as a symbol for resurrection and hope." I have seen this in Pat before; it is a reluctance to address religion directly. It seems to be a shy withdrawal, but it is also a respectful one: How does a person speak about the sacred? But as I read that last question over again—"Is the kite a symbol of man or man's soul?"—I considered another possibility. Pat was making room for doubt: The kite could just as easily represent the body—the

"sack of bones" and the "hank of hair"—as the spirit. By enlarging the question, Pat emphasizes that there isn't one answer.

In another passage of the early sermon, there is a further moment of introspection—exploring once again her doubt in the face of religion. She wrote:

> Sometimes our faith seems to be
> holding us down
> holding us back
> keeping us from being free.
> Actually our Faith is what holds us UP.
> As the string holds up a kite.
> FAITH HOLDS A MAN UP.

And yet Pat loves the search. It does not discourage her not to have an answer; on the contrary, it pushes her forward. On the closing page of one of her exhibition catalogues, above a drawing of a child flying a kite, she wrote:

> And so the kite continues to inscribe its mysterious glyph across the sky.
> HIGHER and HIGHER. Yet our flights are an extension not a completion.
> The essential questions remain. May our flights not carry us away from
> what is essential but closer to it.

One Hundred Kites

Pat and her husband, Hall, arrive just as Heather and I finish photographing the kites. Pat has her "breeze case"—essentially a small suitcase containing one hundred red diamond-shaped kites connected by a single thread, what is officially known as a stacking kite. Pat calls this one *A Train of Thought*. I have never flown a kite with Pat before despite how often we've talked of her collection. But today we will try to fly these one hundred kites—if it does not rain. The sky is dark and the air feels moist.

Beyond the house is a big field perfect for flying kites. Pat heads there as it starts to drizzle. The wind is starting to pick up.
I finish putting the kites back into their boxes and store them once more in the shed. I turn to join the group on the field.

One by one, Pat begins to release the kites. This requires great dexterity; she must hold all of the kites and the string in one hand while sending each kite into the air, one at a time, with the other. Each kite goes up in a rush of excitement. Suddenly, all one hundred of them are in the air. It happens within moments. Pat tugs on the line, and the kites go higher and higher. She is in her element.

A huge amount of air pressure pulls the kites—and Pat—to the north end of the field. The wind blows her dress wildly. I go to her to see if she needs help. Heather also moves in to give assistance, but Pat insists on doing it on her own. She knows what she is doing.

The bright red kites fly brilliantly against the dark blue sky. Pat is smiling, her face alight with joy. She looks back at me and says, "Thank you, thank you."

THE BOOK
OF COMMON AIR

A HIGHLY IRREVERENT
COLLECTION
OF
KITES

TOGETHER
WITH

KITECHISM

Pat Hammond's theory of aerodynamics

NAME THEM
THEY FLY BETTER

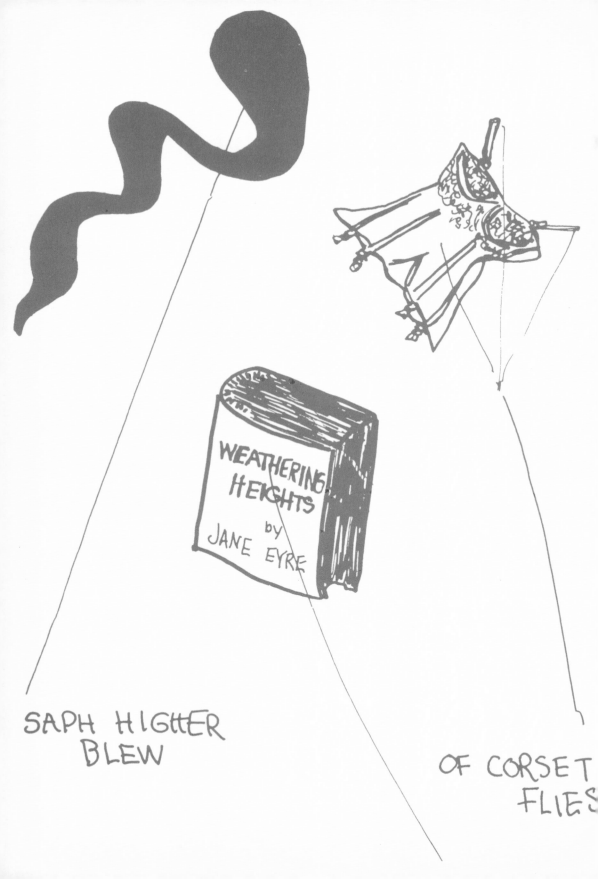

WEATHERING HEIGHTS
by
JANE EYRE

SAPH HIGHER
BLEW

OF CORSET
FLIES

SOAR GRAPES

FLEW
de
COOP

ALAMO HEIGHTS
OR
THE FALL OF THE ALAMO

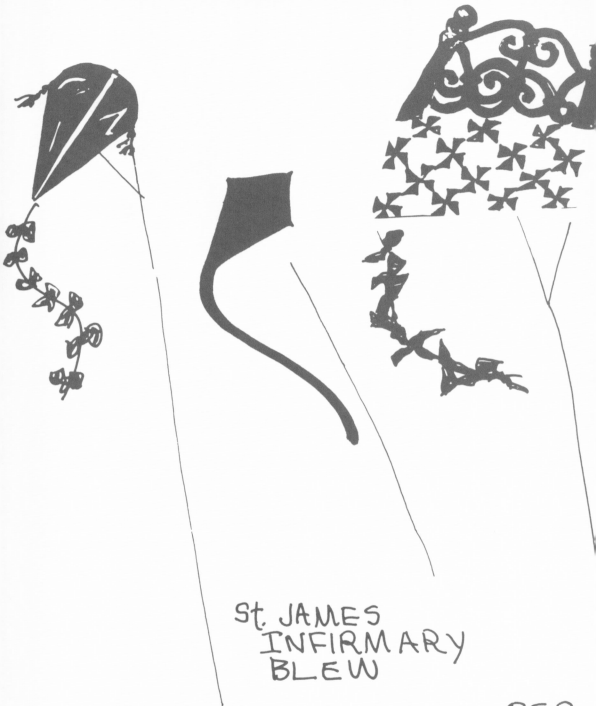

HIER ARCHY

St. JAMES
INFIRMARY
BLEW

BED
SOA

SORE ING SWINE FLEW

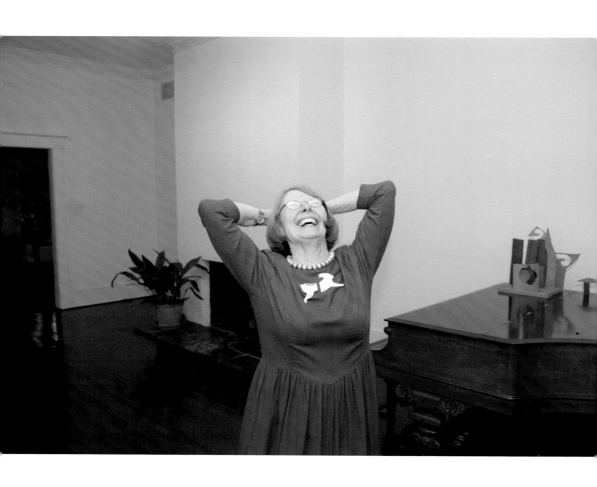

4. Pins and Dresses

Somewhere in the course of this crowded career, I managed to meet Mrs. Hammond, who turned out to be a rather slight, girlish woman, with bright eyes in a lively face, who wore her straight, brown hair in a short bob, held back by a barrette. She had a long-waisted, full-skirted dress with a delicate collar and a strand of lavender pot-pourri rosebuds around her neck. However, she was surrounded by such an aura of energy and enthusiasm that I was put in mind of Dorothy, en route to the Emerald City of Oz, via cyclone—with just a dash of Peter Pan. It goes without saying that when she opened her mouth, she made instant sense.

—Margaret Cousins, reviewing Pat's kite exhibition *More Than Meets the Sky* at the Witte Museum of San Antonio, 1987

Picture a silver sphere. In its reflection you see yourself inside a bare white room. The sphere is small, about two inches wide. On the surface you notice a small dot that takes a second glance to find. Now, imagine that this small sphere is a pin on Pat Hammond's dress. The pin is extraordinarily beautiful, a gleaming silver disc with no marks at all except for the infinitesimal spot. It is elegant in its restraint. She is wearing it as she welcomes you into her home. When you ask about this pin, she invites you to make a guess.

Because Pat loves π and this is a circle made of metal, you ask: "Is it a 'π tin'?"

"No. It is not a 'π tin.'"

"Is it a 'silver plate'?"

"No. Not a 'silver plate.'"

After a moment, she lets you in on the secret: It is the planet Venus passing in front of the sun on June 5, 2012. The small dot is Venus in proportion to the sun at that moment. But Pat has given the sphere multiple names: One is *Spot On*, and another is *Public Sphere*.

The *Venus* pin is one of many in Pat's collection. Every day she wears a different pin on her dress. She keeps them on a wall in her closet, each hanging from a small hook. They cover the wall from floor to ceiling, and more spill out onto the bathroom counter. Each pin is different, but they share common themes: bees, boxes, kites, and fossils. The pins, of course, often represent puns, like the heart-shaped pin she made out of felt and called *Heartfelt*.

As long as I've known Pat, she's always worn a pin and a dress. I can

easily imagine her striking figure: a woman in a long dress that tapers at the waist with a wide collar, a pin on her chest and her hair in a bob.

Unlike with her other collections—where she can point to the very moment her interest was sparked—she can't remember when she first fell for pins. But she has a general sense of the beginning: The story of the pins starts with the story of her dress.

"I was just a terrible tomboy. And my mother was *not* a tomboy," Pat recalls. "My mother loved to buy clothes and she also sewed. I am sure I broke her heart."

Pat talks about her mother often, especially her sense of style and her excellent cooking. She also tells stories about how her mother picked out her clothes for her as a child, and even sent her dresses later, after she had grown up.

"It was so wonderful," says Pat. "She had good taste—taste that I liked. I knew she wasn't going to make me wear something that I really didn't like. And then when she died, I thought, 'I've got to figure out a way to get dressed without going into a store, going into a small room and having a perfect stranger helping me.'" Pat decided she would continue to wear clothes along the lines of what her mother had urged her to wear. It made life simpler—and, perhaps more to the point, she hated shopping.

"I had this one dress that was raw silk," explained Pat. "It was cool in the summer and warm in the winter. You could wash it. It is just this fabulous fabric. And I thought, 'I'll just get one dress and change the color.'"

She had a tailor make several dresses in the same pattern in raw silk and cotton. This became Pat's uniform. To this day, if you look in Pat's closet, you will discover dozens and dozens of bespoke dresses, some with long sleeves and some with short.

Pat has always accompanied her dress with at least one piece of jewelry. She likes to wear large beaded necklaces made from silver or stone. She has a few unusual necklaces of her own design. On her bathroom counter is a "dime-ond necklace" made of real dimes; next to it hangs a horse tooth necklace. Displayed on a wall downstairs is a necklace made from the vertebra of a rattlesnake.

But without a doubt, pins are the most extensive part of Pat's jewelry collection. The pin adds a colorful flourish. And because it is the one part of her outfit that changes, it gives Pat a chance to assert her own eclectic style using her dress as a consistent canvas. Every day she exhibits something new. She designs and often crafts the pins herself. She used to keep Krazy Glue and backings in her purse so that if she found something on the street that she liked—or something in the hands of a visitor—she could take it and make a pin out of it.

Box Top, *Box Kite*, *Boxed N*, and *Chip Off the Old Block* are the names of a series of pins made of boxes with different shapes cut out.

Pat also sometimes wears *A See-Through Top*, a box top with an open lid, which, she explains, "is fine for a person of my age to wear." *Time Beeing and Bee on Time* are from a series made with bees and clock faces. Sometimes these pins are not funny but startling in their sentiment: She once made a silver pin in the shape of a heart; it was cut down the middle and open at the center. On it she etched these words: "Unto whom all hearts are open, all desires known, and from whom no secrets are hid."

These "exhibitions" are temporary—most of them only last a day. Some pins are inside jokes. Every year, for example, Pat buys a fossil on her birthday—"to make me feel young," she says—and makes a pin out of it. Some commemorate a certain time or place. Pat's son Robert helped start the High Line park in New York City—an accomplishment of simple grandeur not lost on Pat. The first time Robert took Pat to visit the site of the High Line—which was, at that time, a derelict elevated railroad on the far west side of Manhattan, overgrown with wildflowers—she picked up a small rusty piece of metal and made it into a pin.

She loves taking humble objects and giving them a second meaning. "My basic philosophy of anything—of everything—is, if it only has one use it is not useful." When she says the word "useful," she does not necessarily mean "functional" in a mechanical sense. She includes metaphor as well: Metaphor is functional if, for example, it lightens the burden of a heavy heart.

Pat's explanations of her pins are an integral part of the experience; many of them are only funny if she is both wearing and narrating them. In this way, the pins are a performance. Pat is engaging an audience, even if it is only an audience of one. She *wants* you to ask about the two naked silver arms dangling from a soldier's medallion on her chest. And she will have a perfectly timed witty response when you do: "It's the right to bare arms!"

In fact, without Pat, many of her collections lose their value: The fossils are just fossils, the honey is just honey, the folk art is old and dusty, and the pins are just dinky pieces of metal with funny names. Pat is an integral part of the experience.

My colleague Heather Fulton once compared Pat to the performance artist Carol Lee Schneemann. In one of her performances, Interior Scroll, Schneemann rolled up a poem she'd written and stuck it into her vagina as she was menstruating. She then pulled out the poem on stage and read from it. It's almost absurd to think of this gesture in relation to Pat's homespun, childlike fixations.

However, both Schneemann and Pat are making statements about things that matter but are overlooked. In Interior Scroll, Schneemann is making a strong point: Menstruation is not shameful. She brings to light

something hidden and private; in doing so, she claims it as a source of empowerment. Menstruation is a real mark of womanhood, in contrast to a chauvinist depiction of women as objects of sexual fantasy.

Pat's statements are not graphic—or overtly political—but she shares with Schneemann a desire to change the way people see things. A children's toy is a metaphor for youthful discovery; a fossil is a metaphor for timelessness; an animal specimen is a symbol of mortality. "I think Pat sees things through such a different lens," Heather said once. "It is a very gentle way of asking people to open their eyes: 'Don't ignore the real beauty' . . . I think she just tries to find ways to make people observe this without trying to shove it down their throats." She uses her body, not aggressively, but as a frame for making statements about family, nature, and time—all by means of women's clothing. And Pat uses humor to get her point across; it helps to disarm her "audience." With her puns and magic tricks, she captures people's imagination and invites them to come play.

Pat is an unconventional feminist. She both conforms and doesn't conform to traditional gender roles. Her art, like her life, is a contradiction of sorts. She is a tomboy by nature but doesn't mind wearing a dress. She hates fashion but she likes wearing jewelry. In fact, her husband sold estate jewelry, but Pat has never wanted to wear the more traditional pieces. She prefers to wear trilobites and rusty wires, expressions of important things. She does not protest the traditional gender roles that largely define her life—but she does poke fun at them.

Pat was born in 1937 and came of age in the 1950s. She was bound by conventional notions of femininity that shaped the lives of the women of her time. She enrolled in the Plan II honors program at the University of Texas at Austin, but she dropped out a semester before graduating to get married. She and Hall had their first son a year later. She became a housewife and stay-at-home mom. She married into a prominent San Antonio family and became part of a wealthy, insular society.

These rigid limitations on her life prompted her to find some kind of escape. Her collections became the outlets that kept her from feeling as if the walls were closing in on her. She fought against pessimism by finding things that made her joyful. She fought against labels by collecting objects that embody many meanings. She surrounded herself with the books of great writers and lived vicariously through their experiences.

The poet Emily Dickinson, in particular, became a kindred spirit. Like Dickinson, Pat's life had been constricted to a domestic sphere. Her home in San Antonio, Texas, is the site of her art. She renovated it to make it feel more open. She exposed windows and removed curtains or shades, giving the whole house the feel of a sunroom. When you first walk in the door, you discover a grand entrance room. It is painted white and the walls are bare. It has dark wooden floors, and the only piece of

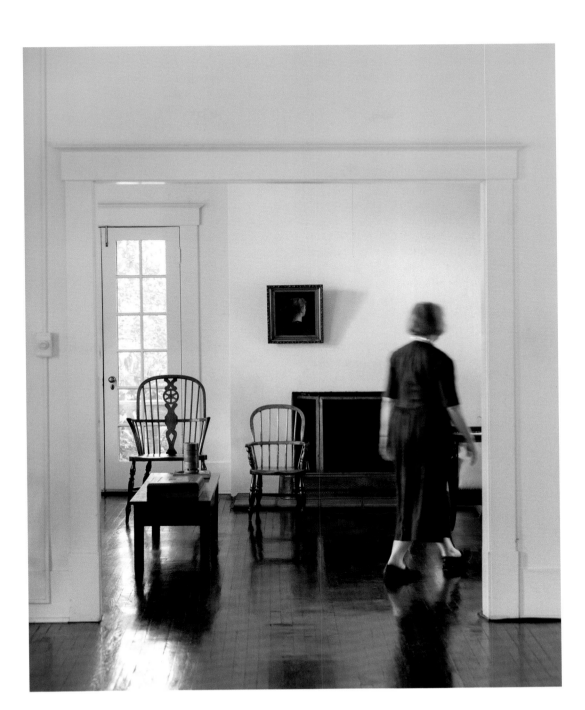

furniture in the room is a grand piano. This is a dramatic contrast to the rest of the house. It feels like a gallery space, and that is also how Pat uses it. She always has a different object displayed—either on the bare walls or the grand piano—to capture your attention.

The spaciousness of Pat's front room is balanced by the busyness of the others, where her collections are grouped together in contained chaos and organized abundance.

Pat also carefully designed the landscape surrounding her home so that it would feel as if the house was enclosed by the woods. She planted trees and tall shrubs along the perimeter of the property. In 1968, when Pat and Hall first moved into the home—originally built by Hall's grandmother in the 1920s—it had a traditional lawn. Today it is surrounded by a forest of live oak trees, Spanish oaks, mountain laurels, Chinese plums, and a few sweet olives. The house can no longer be seen from the street.

Pat's home, like her pins, is an expression of her personality: simultaneously open and introverted. She opened her home to nature but closed it off to the outside world. Ultimately, her world is private, yet she yearns to share it with others.

Consciously, Pat creates a subtle transition between private and public. Her thoughts are manifest on the pins she wears on her chest. She takes the trappings of domestic life and breaks them apart to create a new expanse of ideas. Immersing herself in double meanings, she seeks a world that reaches far beyond her home. On the window of her upstairs living room, she etched a hidden message, a quote by Confucius, in the glass: "I live in a very small house, but my windows look out onto a very large world."

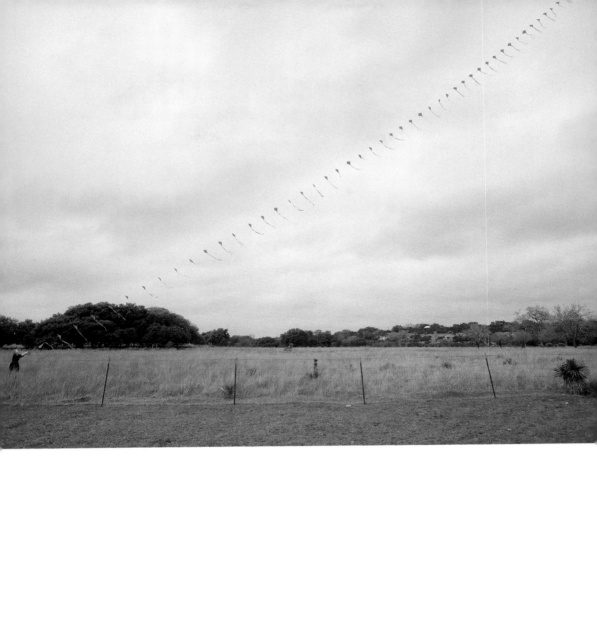

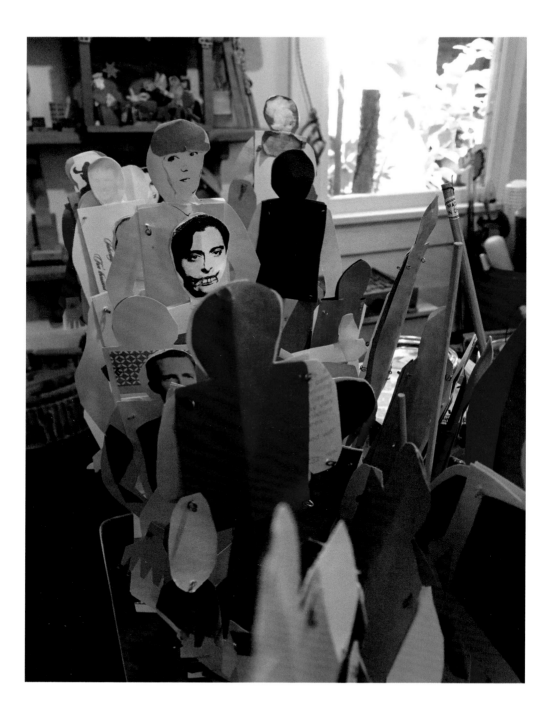

5. Memory, Knowing, and Tops

Bring up from depths of memory the mass of little remembering, stories of seemingly unimportant happenings which make up the picture of a life.

—Rita Halle Kleeman

On our last visit, we talked about memory and knowing. "You said that memory needs housing," I say to Pat. "It cannot stand on its own. It needs basic structure." I set my notes down on the table. These are the important points, I say, since we are sitting, conveniently, next to the bowl of arrowheads labeled IMPORTANT POINTS.

Pat has fascinating ideas about memory, but she is often reluctant to talk about them. As I read the list of important points back to her, I see her withdraw a bit. She prefers not to enter a subject in a straight-forward way. Maybe she doesn't like the feeling of a conventional interview; maybe she needs to feel a genuine sense of inspiration within the conversation.

I struggle to offer her a way in. I remember one of her wordplays from a previous visit: "patterns" as "pat-turns." Pat loves this pun because it is an allusion to her collection of spinning tops. I offer another assist: "You said in our last conversation that you used to make tops that you would turn every day?"

"I did!" Pat says with a smile. I can see the enthusiasm in her body as she almost jumps out of her chair. "Do you want to see them? They are in the basement."

We set aside the big questions for now and go down to the basement.

The door to the basement is at the back of the house, underneath the staircase. A basement is a rare sight in Texas, where most houses are single-story ranch houses. The staircase leading to the cellar is dark and musty. It smells like earth. Along the staircase are boxes filled with what look to be other assorted collections, inventions and gadgets and materials; I realize it's possible that I have only just glimpsed the beginning.

We only walk down two steps before Pat halts suddenly at some empty boxes of laundry detergent. "You see this? There is a poem by somebody, and the last line is 'She moved from cheer to joy to all.' And this is *Cheer*, *Joy*, and *All*," Pat says as she lifts each of the detergent boxes to show me the brand names. "Who said that? Anyway, isn't that beautiful?" she asks before turning her attention elsewhere. "And this is a

kite." She picks up a tiny kite connected to an antenna. It is small enough to fit in her purse. "I can fly that one just about anywhere."

I have seen these little handmade kites before. Pat makes them from personal items that have meaning for her, like wedding invitations. She often gives such a kite to a friend who has shared the experience with her.

We uncover another box filled with the remnants of science experiments. I pick up two bottles of water connected by a tube; it looks a bit like an hourglass. When you turn the tube upside down, the water creates a whirlpool as it flows from the top to the bottom. "All of this stuff is related to air or wind," says Pat. "I used to take these to the school, ostensibly to talk about kites, but really I was talking about everything." Just as she is doing now.

"When I would teach at the elementary school, I would have a piece of newspaper, and I would say, 'If I took off all my clothes and just had this piece of paper, I could walk across the room and not be naked. The air pressure would hold the paper to my body.'" This certainly caught the kids' attention—they were riveted by the image of their instructor walking naked, but they had also unwittingly just taken in elements of Bernoulli's principle. The newspaper wouldn't have dropped; instead it would have seemed to defy gravity, because the air pressure would have decreased as Pat moved across the room.

So we've come from a jerry-rigged hourglass to Pat walking naked to Bernoulli's principle; Pat has a way of weaving it all together seamlessly. I wonder if all of her objects and stories connect in some hidden and meaningful way. I half expect Pat to someday hand me a grand manifesto written on index cards linking everything together. Maybe I'm missing the one dot that needs to be connected. Maybe there is a single thread running through it all.

It seems that Pat has entertained this idea too. There was a time, many years ago, when she began to talk obscurely about "the project." At the time, Pat asked Kim Stafford, the son of her friends Dorothy and William Stafford, to help her organize all of her written files, which flow voluminously from piles in her upstairs office and studio. If only she could get it all organized, she claimed, then she could complete "the project." But what this "project" was we will never know; Pat herself no longer remembers.

Finally we make it to the tops. Hundreds of tops fill three large Plexiglas containers on the cellar floor. The tops are made from round discs of metal with a matchstick inserted in the center for a spindle. Many of them are rusted now. Each top is covered with a white piece of paper and a title—usually one of Pat's beloved puns. We read them aloud.

You're top notch! is written across one; *Don't be Topless; Oliver Twist.* The puns go in all directions. *How many mystery writers does it take to change a light bulb? One—but she needs to give it a good twist.*

And *A grandmother should never be topless*. (She will also wear a plain top as a pin, hoping someone will ask about it so that she can reply, "My grandchildren don't want to see me topless.")

Pat has loved tops ever since she was a little girl. She remembers playing with them on the schoolyard. When she was a child, boys played with tops or jacks. Girls played hopscotch. Pat didn't like hopscotch, so she joined the boys.

There were different varieties of tops. Most were metal. The metal ones had a screw that you could pump. When you pumped the top, it made a spiral, and the top would begin to spin. Some tops you could hold in your hand with a string attached to your finger so you could throw it down. These were used in the playground battles that Pat heartily participated in.

Her interest in tops revived about fifteen years ago. She was inspired by the "turn of the century"—when she decided to make a top every day for one year to celebrate the year 2000.

As always, Pat is intrigued by the object itself; she has found many meanings for it. A top feels like a riddle. It seems to move fast and slow at the same time. It's wide in the center and narrow at the bottom. It is disproportionate yet balanced. A top spins on its axis like the earth or the solar system around the sun, or the way our galaxy spins around a black hole. The metaphor is not lost on Pat. As we spin tops together on the basement floor, she says, "You know, we are all spinning and don't realize it."

We finish in the basement and return to the kitchen.

I sense a shift in her mood; she seems more receptive. I read aloud again from my notes. "Last time we talked about patterns, memory, questions vs. answers, and discernment, which is the power or faculty of mind, the power of viewing difference in objects and their relationships; acuteness, sagacity and insight."

I can see the gears turning in Pat's mind. She thinks for a moment. She has a question but then forgets it. "If it's worth something, it will float back up; it's a floater." This is a favorite expression of hers—a *floater*; she uses it to describe the thoughts that stray before she can articulate them. She has always had difficulty remembering certain things—how to spell her son-in-law's name or just a passing notion. This exists apart from the dementia: If it's a floater, the memory is still with her, and she trusts that it might surface again eventually.

"Questions and possibilities are not Siamese twins but fraternal," she says finally. "One word kind of enhances the other. There is a relationship between them, but each one is describing a unique process. Asking a question is not the same as possibility. Possibility is an experience, something new, or the idea of something new.

"The question demands something else. An answer. But I just love the question. I love to play with the questions.

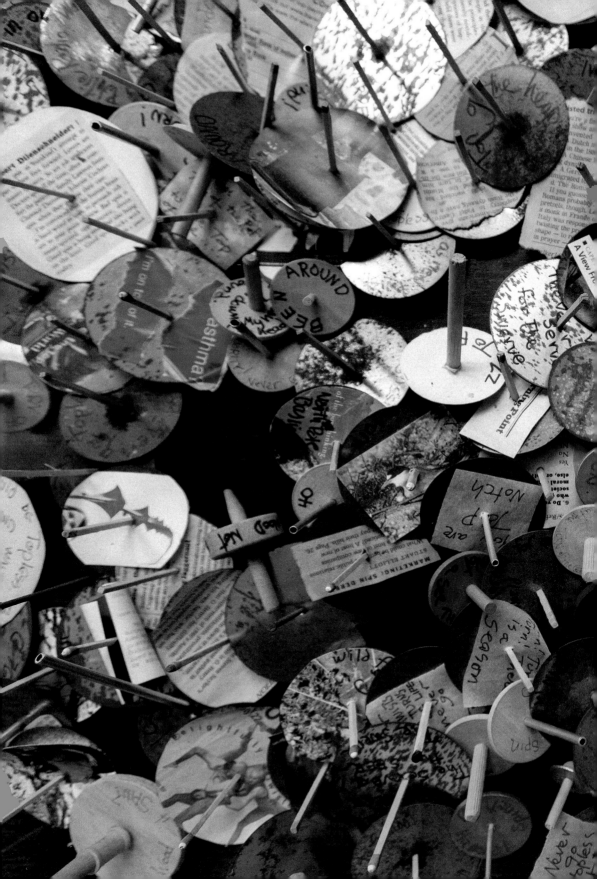

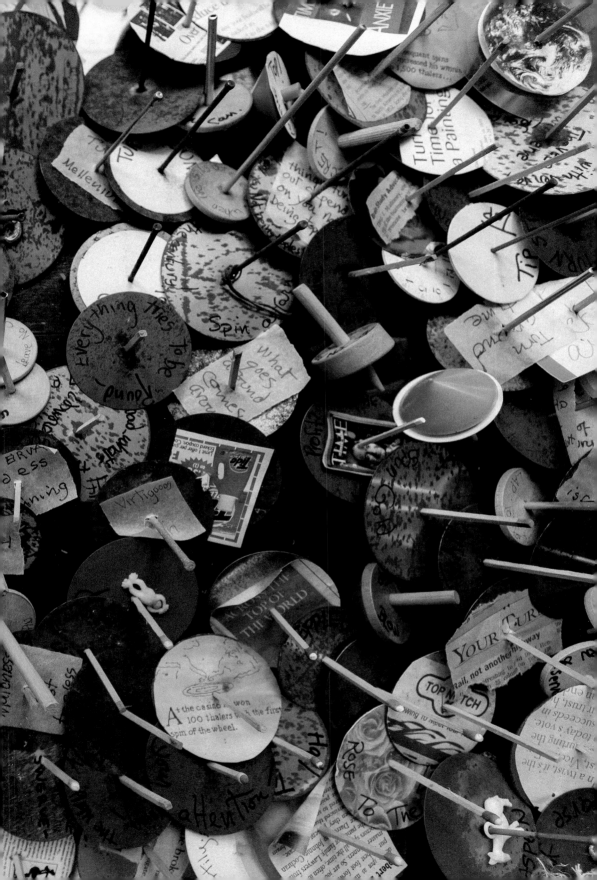

"In school you are judged on how well you answer the question. But really you are being judged on how they wanted you to answer. It is a very narrow idea of what is important."

For Pat, having an answer at the ready is the opposite of learning. If you have an answer, she says, that "closes the search."

"Asking questions is a skill," I suggest. "And there is a kind of skill to curiosity too, to opening yourself up."

"I could think about that for a long time," says Pat. "A question implies you don't know, or you are asking, but gently. You are not just saying I'm an idiot . . . You know, in life's great pageant, for many, many years they didn't have the concept of question and answer."

I ask Pat if she believes memory shapes identity. I explain the Buddhist word *sanya*, which translates as memory or perception. *Sanya* is one of the five aggregates or "heaps"—in addition to body, feeling, thought, and consciousness—that constitutes our sense of self.

"Well, memory does shape our sense of self," she replies. "You have the memory of being someone's child or bearing a child. Memory is so interesting. It sounds like too much of a gloss, but when people say memory loss—it sounds like all memory is gone, vegetative—but that's not true because you can still breathe without the memory of the last breath, and the rote-ness of living still goes on without the memory."

She continues: "But memory is so vast and some of your knowing is so . . . you can't quantify it for sure: yes or no. It is almost a scent. Like a dog can remember that you beat him or fed him. But it's not like he would have the thought, 'I wish you'd buy better dog food.'"

Somehow we have come full circle, back to the subject of memory that Pat had sidestepped earlier. Perhaps there is now something to ground the conversation because we've just encountered so many of her own memories downstairs in the basement. She begins to talk about what memory means to her—right now.

"I know it is progressive, but I hope it is slow, because I am enjoying . . . "—here she trails off. But I know what she is trying to say. There is an aspect to the dementia that Pat enjoys. It's a difficult thing to admit. But the memory loss, at least at this point, keeps her from overthinking minor problems as she used to do. Now they slip away. But more importantly, there is something about Pat in particular that lets her enjoy this state of mind—because she has cultivated such a nimble and optimistic attitude, she views this as almost as an experiment. She doesn't quite know what is going to happen, but so far she is willing to relish the ride.

"And you know, you don't ever have any control over memory," she says assuredly. "You think you have control over it, but really you don't." Pat looks at me and says: "I am glad what is happening to me is happening to my mind and not my heart."

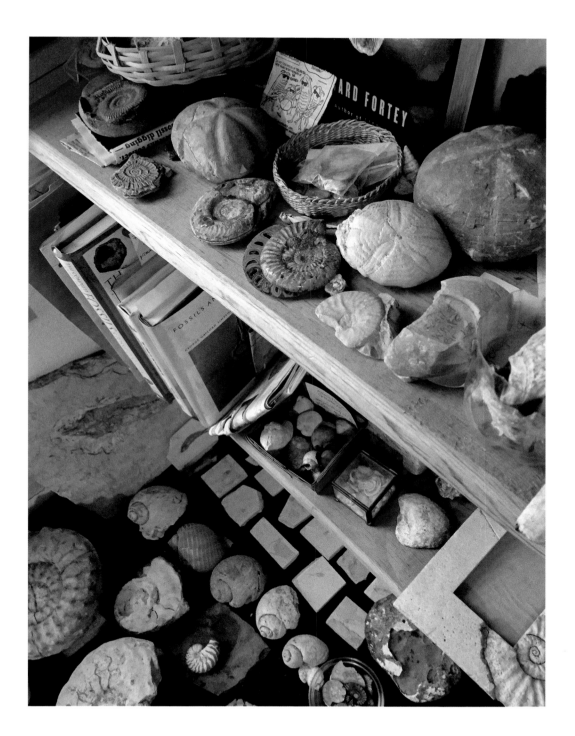

6. Heaven Below

Some keep the Sabbath going to Church—
I keep it, staying at Home—
With a Bobolink for a Chorister—
And an Orchard, for a Dome—

Some keep the Sabbath in Surplice—
I, just wear my Wings—
And instead of tolling the Bell, for Church,
Our little Sexton—sings.

God preaches, a noted Clergyman—
And the sermon is never long,
So instead of getting to Heaven, at last—
I'm going, all along.

—Emily Dickinson, no. 236

I visit Pat one day and discover a small twig pressed against a piece of blue paper. The twig and paper rest on the inside of a cassette tape cover, which serves as an impromptu display case. Pat holds the twig up as though presenting a family heirloom. "Look at this. Isn't it beautiful? I've been looking at it all day."

As I study the twig, I see that it has six or seven distinct hairs in a row. The hairs stand on end like a line of soldiers, and on the tip of each hair is a tiny round dot.

I ask Pat if they are eggs. What tiny little creature could have laid such a perfect line of eggs?—if they are, in fact, eggs.

"I found this on a branch. I snipped it off right at the edge and carried it here," Pat says. "This twig was on the ginkgo tree. You can't even see the tree; it is so *negligible*." Pat points to the yard. We look out the window of the dining room, and across the yard I can make out a tiny stick of a tree that is all twigs and no leaves.

The ginkgo tree is dwarfed by surrounding oaks; the tiny little eggs on the twig are even more "negligible."

On an index card, Pat once wrote a line by Johann Wolfgang Von Goethe: "Thinking is more interesting than knowing, but not as interesting as looking." Pat looks for subtle changes like the budding of trees or the dropping of acorns. In these things she finds beauty and humor.

It is fitting that Pat has an affinity for Emily Dickinson, whose poems describe small events and elements of nature, modest yet splendid. Dickinson makes an unexpected drama of minor things. And she reveres nature as something both ordinary and divine. Dickinson's poems are a window into Pat's world, a world that is at once as mundane as dirt and brimming with joy.

One poem, number 191, seems to particularly capture Pat's devotion to nature:

> The Skies can't keep their secret!
> They tell it to the Hills—
> The Hills just tell the Orchards—
> And they—the Daffodils!

Pat handles all of her discoveries in nature as lovingly as she does the little twig. She wants to let others in on the secret too.

Though the ginkgo is a squat little tree, the rest of the yard is lush and the arching oaks trees create a canopy of green. In the summer, the trees offer an oasis of shade from the heat of the Texas sun. "When we moved in," says Pat, "the first thing we did was plant things that would stay green on all four sides, with little six-inch saplings." Those saplings are now almost as tall as the trees. Pat points to a forty-foot-tall Spanish oak that towers over the yard. "This tree Jeff and Mills planted as an acorn," she says, referring to her two oldest kids.

Pat looks around at the loquat trees, which are already loaded with young fruit. When they are ripe, the fruit will be bright yellow and very sweet.

"I just hope I live—I want these trees to live as long as I do. I don't know if they are in a long life category. I don't think they are," Pat says, and then adds almost as an afterthought: "I never dreamed that I would worry about living longer than a loquat."

"This world is not Conclusion," writes Dickinson (no. 373)—and Pat has rewritten this on a scrap of paper:

> This world is not Conclusion.
> A Species stands beyond—
> Invisible, as Music—
> But positive, as Sound—
> It beckons, and it baffles—
> Philosophy, don't know—
> And through a Riddle, at the last—
> Sagacity, must go—

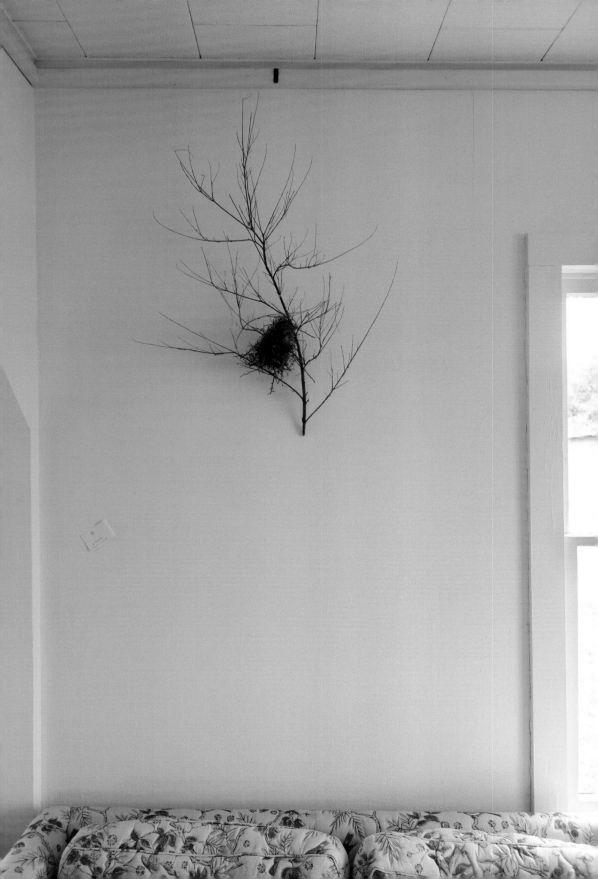

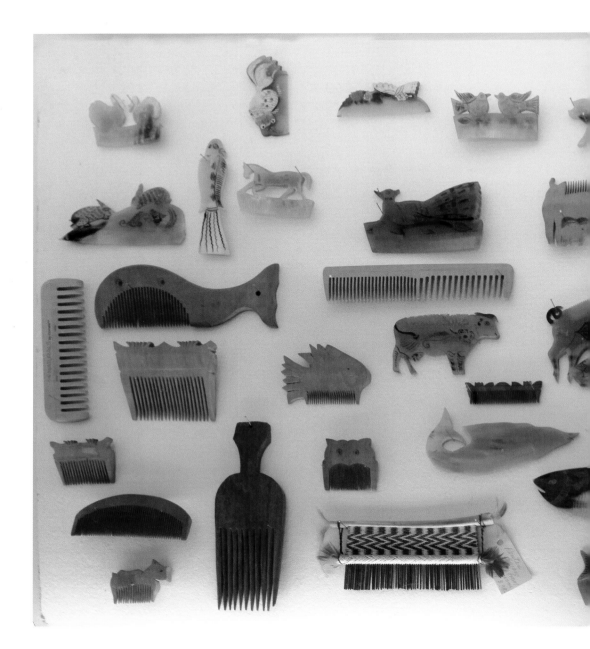

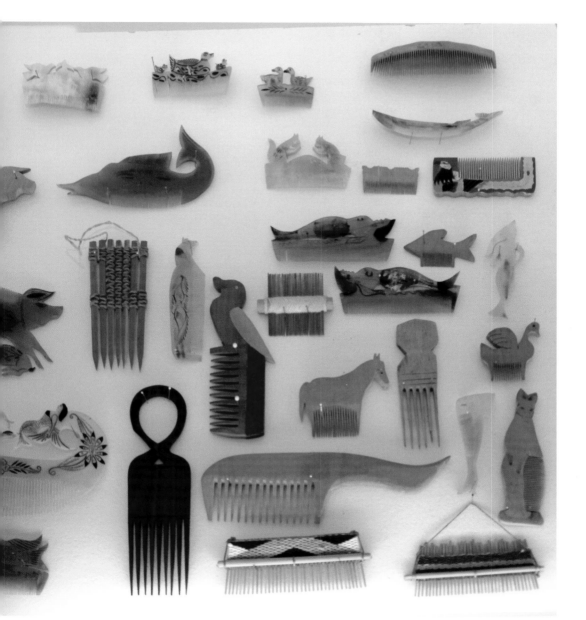

This is where Pat's transcription ends. But the poem continues:

> To guess it, puzzles scholars—
> To gain it, Men have borne
> Contempt of Generations
> And Crucifixion, shown—
> Faith slips—and laughs, and rallies—
> Blushes, if any see—
> Plucks at a twig of Evidence—
> And asks a Vane, the way—
> Much gesture, from the Pulpit—
> Strong Hallelujahs roll—
> Narcotics cannot still the Tooth
> That nibbles at the soul.

Dickinson's poem embodies Pat's attraction to the unknown. It is not a bombastic faith or a treatise on divine mystery. "Faith slips—and laughs, and rallies— / Blushes if any see—": This is, no less, a description of Pat's faith. It is wobbling and hopeful, self-conscious and shy. And it is steadied by humor and buoyed by moments of ecstatic joy.

The last phrase, "the Tooth / that nibbles at the soul," implies that religious expressions are human—and thus flawed— attempts to address the pain of the human condition.

Perhaps the desire to understand the unknown—to which "Men have borne / Contempt of Generations" and even given their lives—is compelled by the existential pain of the human soul. We seek heaven not out of curiosity but out of necessity.

Pat's life's work too may be animated by a desire to remedy a pain she feels in her heart. But she does not seek salvation in gospels or liturgies. Instead she finds it in shrunken acorns and fragile spiderwebs, as Dickinson found heaven in the song of the bobolink and in fields of buttercups.

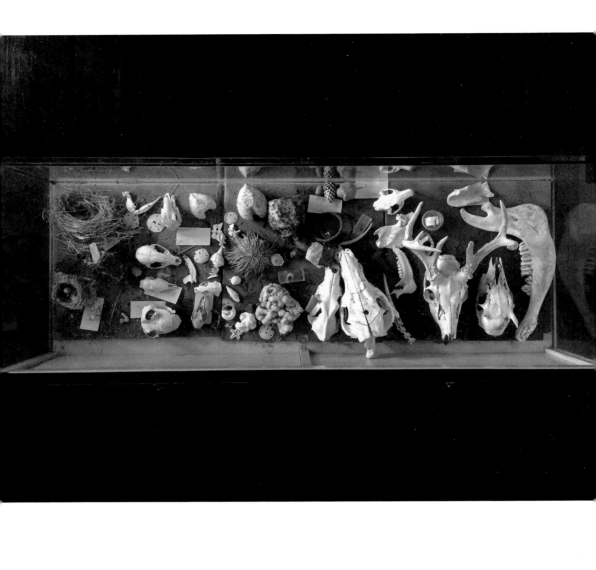

Epilogue
Memento Mori

Demean	Memory	Memoir	Memorable
Demeanor	Memento	Memorabilia	Memorandum
Demented	Memento Mori	Reminding	Memoria

In the fall of 2014, as Pat waited in her doctor's office, just before being given her diagnosis of dementia, she began work on several eight-page books about memory. She listed words relating to memory or dementia alongside their textbook definitions. Above is a selection of words culled from these books. "Memento," she writes, "Something to awaken memory, a hint, token, warning, or memorial." And between the lines she writes in small letters, "I wish it was that easy—."

On another page, she writes the word "disability" followed by variations of words that end with "-ability." She writes, "Affability, amiability, durability, disability, (?)lovability . . . Viability, capability of living—But how?"

She writes out the definitions of dementia alongside related words: for example, "Demean: to debase, to lower, to degrade . . . To deal with—to maltreat." The eight-page books are probing. The reflections are mostly somber but at times funny.

She dedicates a whole page to the word "forgettery," which I thought she made up but later discovered is a real word that means the faculty or power of forgetting. (In fact, she provides an example of its use from an 1863 article from *Harper's*: "He had a bad memory and a first rate forgettery.") This is typical of Pat's character. She takes an apparent defect and turns it into a special power.

Most of the time, Pat deals with her dementia with a good sense of humor. Just as she used to joke about aging, saying she enjoyed it because it was so easy to exceed the expectations of others, she also can make light of dementia; she likes to say that the best thing about losing her memory is that she gets to rediscover everything she loved before. Once I called her to ask if she could explain Bernoulli's principle. Her response: "Chris, you are talking to a person with dementia—you can't expect me to explain something like that!" Of course, within a few minutes she explained it perfectly. Sometimes I forget about the dementia entirely and ask stupid questions like "Do you remember when . . . ?" She never fails to scold me: "I have to teach you to not ask me that question!"

Some days she can remember everything. Other days she may ask the same question several times or forget something that only just happened. On those days, I know the dementia is real.

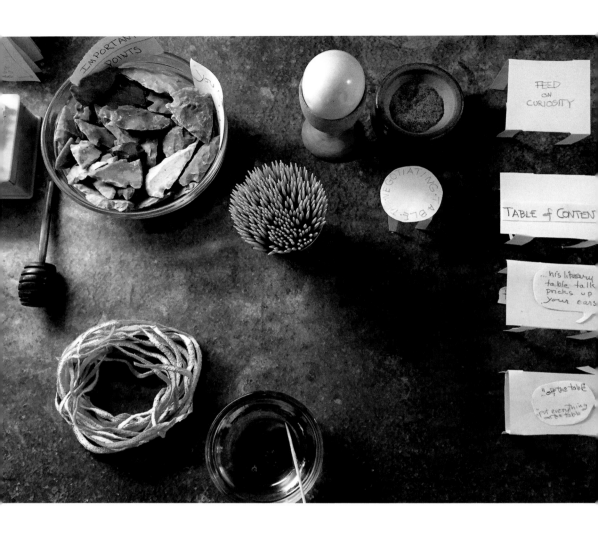

But the illness has not fundamentally altered her personality. It hasn't diminished the satisfaction she gets from her collections. Nor has it changed the way Pat relates to the world. The same joy and excitement of discovery that she derives from a small act of nature still resonates. In some ways, it even protects her from the vicissitudes of her illness. Most people would shrink away from outward signs of aging and sickness. But Pat understands that what is happening to her body is the same process of natural decay of the plant and animal specimens that she so ardently collects.

In one of Pat's eight-page books on memory, she writes, "Memento mori . . . an object used as a reminder of death." *Memento mori* is a Latin phrase that means, literally, "remember to die." And many of the objects that Pat collects are gentle reminders of death. The dead gecko on a note card is a memento mori. As are her stuffed owls, hummingbirds, and sparrows, all of which she taxidermied herself. And the trilobite fossils she collects on her birthdays.

Pat's willingness to look at death affords her vital insights into life. They are simple and profound: *Don't take yourself too seriously, because you are just bag of bones and a hank of hair!*

In her living room upstairs, Pat has an acrylic box with three drawers. Inside the top drawer is a white witch moth, the luminous white of its wings elegantly patterned with a zigzag of deep brown. Below it are shards of rust that Pat took from iron casings on the High Line. There is a saying, or so she tells me, that goes, "where neither moth nor rust destroys." This is an allusion to Matthew 6:19–21: "Lay not up for yourselves treasures upon earth, where moth and rust doth corrupt . . . but lay up for yourselves treasures in heaven . . . For where your treasure is, there will your heart be also."

Pat's most urgent message is that we can find heaven in our own backyard, see something sacred and beautiful in what is plain and ordinary. The objects she collects are sacred because they represent something particularly meaningful to Pat.

She is deeply satisfied by the idea that something slight and insignificant could illuminate a grand truth. This is a contradiction that gives meaning to her life—that even someone ordinary and small, plodding along as best she can, can offer a lesson that gives meaning to the whole.

Pat's revelations have been profitable not only for her but also for the people she shared them with: her family and friends, children and grandchildren, and everyone who visited her exhibitions and heard her talks, from first-graders in elementary school to engineering students at Texas A&M. Pat's strength as an artist is in conveying her insights in a way that captures a feeling of delight. With humor and delight, she opens herself again and again to the discovery of something new. Her wisdom is in her questions and her willingness to admit humbly that she does not know. She invites us to do the same. Perhaps then we too may dwell in the possibility of things unknown.

Mrs. Hall Hammond delights in entertaining informally, whether it be a family picnic or a dinner party for a group of friends. A favorite spot of all who enter her home, her kitchen is a special place for young son Robert, a great mud pie chef himself, who already recognizes that his mom is a cook par excellence.

Afterword

Robert Hammond

I always knew my mother was different from other mothers.

There was always a contradiction at work with her; she was always in a kind of tug of war with convention. My father sold estate jewelry, but her idea of a beautiful pin was a nail gun cartridge affixed to her dress with magnets. And though my mother had a renowned kite collection, one thing we did not do very much as a family was fly kites. As with most of her projects, her kite collection wasn't about the actual activity: it was about the process of making kites, of naming them, of finding the connections with her other projects and hobbies.

My mother had a room full of cookbooks, but I almost never saw her cooking. She did do other things in the kitchen, however. It didn't surprise me when I came home to find a bird decomposing in acid in the kitchen sink so she could add it to her vertebra collection. Or when I would open the freezer on the back porch to find several frozen birds that my mother was saving to taxidermy herself. (It is actually illegal to perform taxidermy in your home without a license, so my mother is still a little nervous about this particular hobby being known publicly.) In college, when I brought my first boyfriend home for the holidays, he and my mother bonded by stuffing the body of a rare woodpecker.

When I was eight, I held an art show in the great front room of our house. My mother and I silk-screened each invitation on the back porch; we exhibited paintings and sculptures I had made over the previous year. Though I do have an artistic bent and have since held a few art exhibitions on my own, this first show was less about any precocious artistic talent and more about my mother's deeply focused enthusiasm and her capacity for seeing art in the drawings and playthings of a young kid.

Some of our other early collaborations seem slightly dangerous in retrospect, like making paperweights out of lead heated over the kitchen stove. Others were more like off-kilter Martha Stewart projects than artistic endeavors, like gathering Spanish moss off the trees at our farm and making Christmas wreaths out of them. She collected bubble-making devices, and invented them too. For her grandest, she combined a bisected tractor trailer tire, a seven-foot PVC super structure, a hula hoop, and a pulley system. You could stand in the center and lower the hula hoop into the tire and then gently raise it, surrounding yourself in a giant bubble.

It's hard to fully appreciate these kinds of things when you are a kid; if anything, I remember feeling slightly embarrassed much of the

time. Sometimes my friends appreciated her collecting more than I did because it often involved candy, magic tricks, or kids' toys (or, in the case of my college boyfriend, the dead woodpecker). Sometimes I wished my mother were more like other mothers, who had more traditional home decorations or played tennis. I later found out that my mother had actually won the country club tennis championship before I was born—only she had never mentioned it to me or even played tennis much after that. I understood this as further evidence that, while my mother likes to compete and be a member of the club, she wants to be able to just as easily step away from this too.

From an early age I remember thinking of my mother as an artist. After taking me to hear Christo and Jeanne-Claude give a talk at a museum in Austin, she gave me their giant book about the Running Fence project. The book was huge and weighed several pounds. It had beautiful pictures of the installation, but most of it was about the process that the two went through to conceptualize the idea, get approvals, and work with hundreds of property owners and local governments, as well as design and build the structure itself. She explained to me that Christo and Jeanne-Claude paid for the project by selling drawings of their ideas, that the actual structure was up for only a little while and that all that remained afterward were the drawings and photos and documentation. Their art form, she explained, was the process itself.

Throughout my twenties, I worked in office jobs at various start-ups. This was probably partly a knee-jerk reaction against the artistic chaos of my upbringing, but my mother's off-kilter influence had never really left me. Walking home from work one day, I found myself buying a box of Dr. Ph. Martin's watercolors from a guy on the street. With these, plus a half-used tub of dark blue house paint, I started making my own art at home, which developed into a full time (if short lived) artistic practice. In a similar instance of impulsive engagement, I was drawn to an abandoned elevated rail line in my neighborhood, and I began a project that eventually became the High Line. In those early years the High Line did not look very promising; back then, I was more optimistic about my art career.

Looking back now on those paintings I did more than a decade ago, I see that every single one of them held multiples—there are multiple boxes and squares and horizon lines—and they are almost always contained within a grid. I am more practical than my mother; I need more order. But it turns out that we both feel, as Christo and Jeanne-Claude must also have felt, as creative and alive when developing our methods as when staring at the end result—perhaps even more so.

As my artistic sensibility came into focus, I was able to see that I didn't want to work in a traditional business job. And as the High Line project gathered steam, I painted less and less. I didn't create the High Line logo or early graphic work; I didn't design the High Line; I didn't even come up with most of the strategies that enabled us to save the rail

line from demolition and raise the millions of dollars required to build the High Line. My creative talent was recognizing the good ideas and bringing people together—making the connections that brought the collection together. In other words, the art form, for me, was the process itself.

"All you need is two," my mother used to say, "to have a collection." That was how she ordered her ever-growing world of materials. Perhaps buying a few hundred pairs of red wax lips is a crazy thing to do—but when she put them on a shelf next to a thousand Dracula teeth, they made all the sense in the world.

What elevated my mother's collections to the level of art was my mother herself. It was her accompanying performance that made the vertebra and red wax lips and Dracula teeth mean something. She wasn't ever trying to build a monument to herself; she genuinely enjoyed the show, and lived in the process. Even after multiple museum shows she is still resistant to the notion that what she creates is art, much less that it should be brought forth for public admiration. And yet here we are trying to capture her and her art in a book anyway.

Once she is gone, the bathtub filled with hundreds of bubble-making devices might cease to be a "bubble bath" and turn back into hundreds of pieces of dusty, colored plastics. The towering stack of books with red covers might no longer be her "well red" books. As my mother's memory fades, so too will the genius of these pieces. Without her explanations and puns and stories, without her animation, these objects return to their everyday forms. In the end, it will all go back to being, as my mother is so fond of saying, "just a hank of hair and a bag of bones."

But is the memory more powerful than the artifact? During my freshman year of college my mother sent me a photo mailed as a postcard almost every day. They were pictures she had taken of things she thought were funny, unusual, or interesting. Often there was a one-line pun or explanation next to my dorm address. It was like a quirky analog version of Instagram. I threw them all away. In this case even the hank of hair is gone but the artwork remains in my memory.

When we were halfway through this project, I grew concerned that we were exploiting my mother's memory loss. We hadn't told her the full extent of our undertaking. Would she ever have agreed to let Chris interview her if she understood their conversations might be turned into a book? Would she have let her collections be photographed if she knew we wanted to exhibit them in a gallery? Was this an invasion of her privacy? I asked my meditation teacher for his opinion. He said it seemed pretty simple to him. "To document is to love," he said. And then I had my own realization: She collects and catalogs to show her love for the things that usually go unseen, and now we are trying to do the same for her.

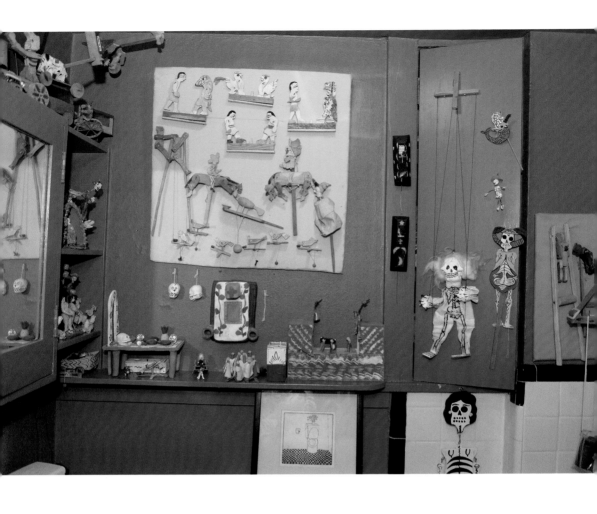

PHOTO CAPTIONS

Cover: *Living* ©2016 Marks Moore

4: Photographer and date unknown. Pat Hammond standing inside a replica of a Hargrave box kite.

8: *215 Argyle* ©2016 Marks Moore

10: *Office* ©2016 Marks Moore. Pat's upstairs work space.

12: *Bedroom* ©2016 Marks Moore. Pat's bedroom library, including her collection of books on kites, air, aviation and aerodynamics.

14–15: *Play Room* ©2016 Marks Moore. A view of the kitchen from the play room. The play room contains shelves filled with magic tricks, toys, and other collections.

17: *Brooms* ©2016 Marks Moore. The back porch contains Pat's collection of vintage brooms.

18: *Chain Letter* ©2016 Marks Moore. Pat usually welcomes guests by spelling their initials with metal chains next to her front door, also known as "chain letters." However, the numbers in this photograph were originally made on March 14 to commemorate the mathematical constant of π.

21: *Well Matched* ©2016 Marks Moore. A photograph of Pat's kitchen counter, which contains an ever changing collection of puns and toys. In this image six match sticks balance on the head of a seventh above the title *Well Matched*.

22: *Beginning of an Eight-Page Book* ©2016 Emily Walter. Pat folds a photograph cut out of the New York Times to make an eight-page book.

24–25: *Eight-Page Books* ©2016 Marks Moore. A collection of Pat's eight-page books sits on the counter in her pantry. She usually makes at least one eight-page book a day.

28: *Thorns* ©2016 Emily Walter. Pat kept a beehive in her upstairs sitting room for fifteen years and harvested her own honey. The bees are gone, but she still keeps a bowl of honey on her kitchen counter next to a jar of toothpicks for easy tasting. "Living is like licking honey off a thorn" is one of her favorite sayings.

33: *Honey* ©2016 Marks Moore. Pat's honey collection.

36: *Kite Lady* ©2016 Marks Moore. Pat flying *A Train of Thought*, one hundred red diamond kites, at the Hammond farm in Blanco.

40–41: Photographer unknown. Pat flying a kite circa 1980.

44–45: Photographer unknown. Photographs from Pat's exhibition *The Kite: More than Meets the Sky* at the Witte Museum in 1987.

51–55: *The Kite: More Than Meets the Sky* ©1977 Pat Hammond. Excerpt from the original catalog for the exhibition *The Kite: More Than Meets the Sky*, which featured a selection of hand drawn kites under the title "The Book of Common Air: A Highly Irreverent Collection of Kites."

56: *Hare Cut* ©2002 Dudley Harris. Pat wearing a pin of a rabbit cut in two named: *A Split Hare*, Hare Assed, Hare Cut or a Good Head of Silver Hare.

61: *Pat* ©2016 Marks Moore. Pat walking in front of a self portrait by her husband's grandmother who built the house in 1920.

63: *One Hundred Kites* ©2016 Marks Moore

64: *Untitled* ©2016 Marks Moore. Containers filled with "Spinning Men," which have the faces of friends pasted onto the front and back, sit in Pat's back play room.

68–69: *Turn of the Century* ©2016 Marks Moore. Pat made a top each day for 365 days in the year 2000 for a work she called *The Turn of the Century*.

71: *Fossils* ©2016 Marks Moore. Every year on her birthday Pat collects a fossil to, as she says, "remind her of how young she feels."

72: *Lambscape* ©2002 Dudley Harris. Mexican lambs made of sugar reading a braille book.

75: *Nidify* ©2016 Marks Moore. A bird's nest adorns the wall of the Hammond farm in Blanco above a small note that states: "Nidify—to make or build a nest."

76–77: *Combs* ©2002 Dudley Harris. Pat's comb collection. (Courtesy of D. Harris)

80: *Living Room* ©2016 Marks Moore. The coffee table of Pat's upstairs sitting room contains animal specimens, fossils, and animal skulls.

82: *Counter Culture* ©2016 Marks Moore. A collection of objects from Pat's kitchen counter includes a bowl of arrowheads labeled *Important Points*, as well as an orange peel, a honey dipper, and a series of paper table tops.

84: 1971 *North San Antonio Times*

88–89: *Bubble Bath* ©2016 Marks Moore. Pat's downstairs bathroom contains a tub filled with her collection of bubbles and bubble machines.

91: *Untitled* ©2002 Dudley Harris. Pat's collection of Mexican Day of the Dead folkart.

92: *Hard Rock* ©2016 Emily Walter

94: *Untitled* ©2001 Cindy Tower; A painting of Pat's office.

96: *Untitled* ©2016 Emily Walter

www.marksmoore.com

Acknowledgments

Many thanks to the entire Hammond family, without whose support this book would not be possible. A special thanks is due to Hall Hammond for his enthusiasm in documenting and celebrating Pat's art, and for supporting this project every step of the way. I am also indebted to Pat's children for openly sharing stories about their mother; Jeff Hammond for entrusting me with Pat's writings and giving me a deeper understanding of her life; Mills Walter for sharing stories of mud pies and handmade lollipops, and for helping me see Pat as a great encourager. I am grateful to Robert Hammond, whose friendly persistence and single-minded dedication guided this project from the very beginning. The insights and careful editing of Nell Casey brought these essays to new heights. The photography of Marks Moore captures the color of Pat's world and brings this book to life. Thanks to Dudley Harris and Emily Walter, whose beautiful photographs give us an intimate window into Pat's home.

This book benefited greatly from all of Pat's friends who contributed stories and enthusiasm for documenting her art, especially Maline McCalla and Naomi Nye. It became a reality with the support of Tom Payton and Trinity University Press. Ali Fujino and the Drachen Foundation, who first asked me to write about Pat years ago, once again provided invaluable support in finding a new home for Pat's kite collection. Lastly, I want to thank my mother and father for giving me the freedom to pursue my dreams. Whether I am binding books or writing about kites, thank you for always encouraging me.

This book and the accompanying exhibition was made possible thanks to the generous support of:

Hammond and Walter Families
Diller-Von Furstenberg Family Foundation
Donald Mullen Family Foundation
Viniar Family Foundation
Charles Butt
Philip E. Aarons and Shelley Fox Aarons
C.S. Waller
Richard E. Goldsmith
The Smothers Foundation
Leo F. Perron Jr
James Family Charitable Fund
Flohr Family Foundation
Fredericka Younger

The Unseen Collaborator

Robert would like to acknowledge the role that his father played in supporting Pat's art throughout her life. His consistent support allows Pat to pursue her passions. She is so different from the wives of his contemporaries and they have rarely shared the same interests but, for fifty-eight years he has loved her and supported her unique creativity.

Selected Bibliography

Bachelard, Gaston. *Air and Dreams: An Essay on the Imagination of Movement*. Dallas: Dallas Institute Publications, Dallas Institute of Humanities and Culture, 1988.

Davenport, Guy. *The Geography of the Imagination: Forty Essays*. San Francisco: North Point, 1981.

Dickinson, Emily. *The Poems of Emily Dickinson: Reading Edition*. Edited by Ralph W. Franklin. Cambridge, Mass.: Belknap Press of Harvard University Press, 1999.

Frisch, Karl V. *Animal Architecture*. London: Hutchinson, 1975.

_____. *Bees: Their Vision, Chemical Senses, and Language*. Ithaca, N.Y.: Cornell University Press, 1971.

Huizinga, Johan. *Homo Ludens: A Study of the Play Element in Culture*. New York: Roy, 1950.

Hyde, Lewis. *The Gift: Imagination and the Erotic Life of Property*. New York: Vintage, 1983.

Lane, Harlan L. *When the Mind Hears: A History of the Deaf*. New York: Random House, 1984.

Murchie, Guy. *Song of the Sky*. Cambridge, Mass.: Riverside, 1954.

Overy, Angela. *Sex in Your Garden*. Golden, Colo.: Fulcrum, 1997.

About the Author

Christopher Ornelas is the co-author of *Wings of Resistance: The Giant Kites of Guatemala*. He published an article on Pat Hammond for *Discourse at the End of the Line* titled "The Magician's Oath: A Conversation with Pat Hammond on Magic, Science, and the Wind." He graduated from Yale University with a degree in Latin American studies. He is an aspiring monk who loves the forest, handmade paper, and chocolate pie.